SOUTHERN
GARDENING
All Year Long

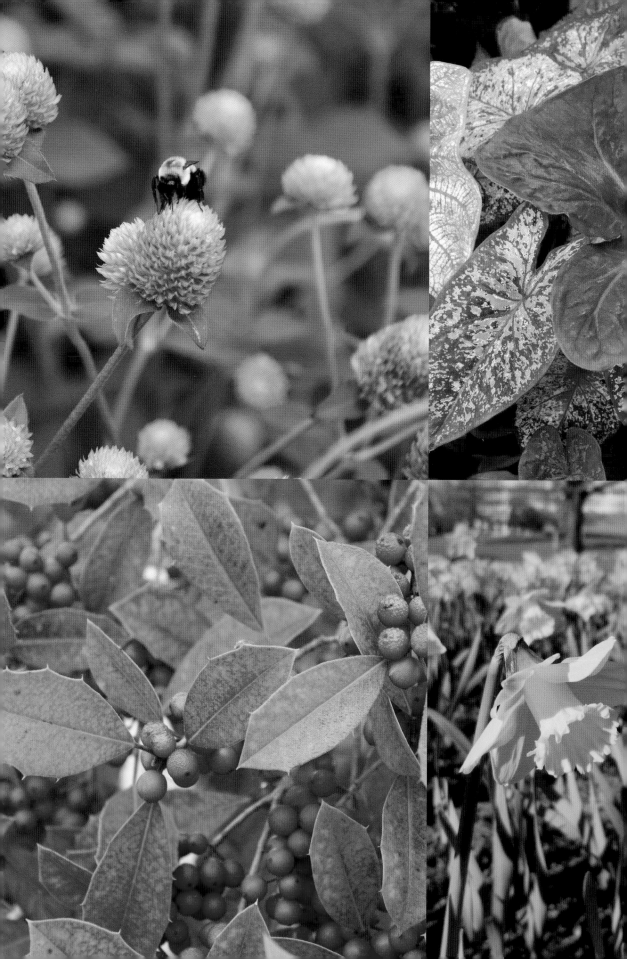

SOUTHERN GARDENING
All Year Long

GARY R. BACHMAN

University Press of Mississippi / Jackson

The University Press of Mississippi is the scholarly publishing agency of
the Mississippi Institutions of Higher Learning: Alcorn State University,
Delta State University, Jackson State University, Mississippi State University,
Mississippi University for Women, Mississippi Valley State University,
University of Mississippi, and University of Southern Mississippi.

www.upress.state.ms.us

Designed by Peter D. Halverson

The University Press of Mississippi is a member
of the Association of University Presses.

All photos by Gary R. Bachman, unless otherwise noted.

First printing 2022
∞

Library of Congress Cataloging-in-Publication Data

Names: Bachman, Gary R. (Gary Robert), 1955- author.
Title: Southern gardening all year long / Gary R. Bachman.
Description: Jackson: University Press of Mississippi, 2022. | Includes
 index.
Identifiers: LCCN 2021034642 (print) | LCCN 2021034643 (ebook) | ISBN
 978-1-4968-3851-3 (hardback) | ISBN 978-1-4968-3890-2 (trade paperback) | ISBN
 978-1-4968-3852-0 (epub) | ISBN 978-1-4968-3853-7 (epub) | ISBN 978-1-4968-
3854-4
 (pdf) | ISBN 978-1-4968-3855-1 (pdf)
Subjects: LCSH: Gardening—Southern States. | Gardening—Handbooks,
 manuals, etc. | Landscape gardening—Southern States.
Classification: LCC SB453.2.S66 B33 2022 (print) | LCC SB453.2.S66
 (ebook) | DDC 635.0975—dc23
LC record available at https://lccn.loc.gov/2021034642
LC ebook record available at https://lccn.loc.gov/2021034643

British Library Cataloging-in-Publication Data available

Contents

From the Author

Gardens are amazing, living creations. They change by the season; they are places to try new things. They allow the gardener to achieve stunning success and realize that failure is just an opportunity to try something else. And they are a perfect canvas to display the gardener's personality.

My horticultural roots run deep. I have undergraduate and graduate horticulture degrees from Clemson University (BS and MS) and The Ohio State University (PhD). I am a Fellow of the American Society for Horticultural Science and named a Great American Gardener by the American Horticultural Society and received the B. Y. Morrison Communication Award. I am also a Certified Professional Horticulturist.

I love plants, and I have built my career around them. I have personally created and maintained my own gardens and landscapes in five states over thirty-five years. I live by my garden motto: "If you're not killing plants, then you're not gardening."

I love gardening, and I love talking about gardening everywhere I go. I have spent the past ten years carving out a unique and trustworthy presence in the gardening community as host of Mississippi State University Extension's *Southern Gardening* online, in print, on the radio, and on television. I never grow tired of unfurling the beauty of gardens and landscapes. And I never grow tired of sharing down-to-earth information and education to help beginning and experienced gardeners succeed. Therein lies the premise for this collection you hold in your hand.

Gardens are never static, so gardeners never sit still for long. And why would you want to, with seed companies and plant developers constantly offering new plants to try?

When I'm writing my column, I struggle each week deciding what to focus on and which plants just have to wait for another week. Regardless of the topic, I do my best to share tips, ideas, and great plants to help both inexperienced and veteran home gardeners get more enjoyment and benefit from their landscapes. This collection offers some of the best of those weekly efforts.

This book takes you through a year in the life of your garden, compiling some of my favorite columns from the more than five hundred I have written. The selections for each month draw attention to activities the gardener can do at that time of year, plants that are blooming, and new selections that have been released. So, if you are reading this book in March, flip to that section to see what could be going on in your landscape, then read ahead to April and May to start planning your next garden steps. Realize this is not an all-inclusive list, just ideas and the encouragement—indeed, an exhortation—to get out into your landscape and *garden*!

While many of these writings originate in my Ocean Springs, Mississippi, home garden and landscape, they are written with the Southeast in mind. My own Heritage Cottage Urban Nano Farm and landscape are my horticultural testing and demonstration facility, where I get to try new plant selections and out-of-the-box gardening ideas for both ornamentals and vegetables.

This book is both practical and common-sense, to make gardening approachable. I share both my garden all-stars and successes, along with plants that did not perform well and ideas I had that weren't so good. So, turn the page and find new ideas to try in your own garden and landscape!

Gary R. Bachman

Acknowledgments

A lot of talented people have contributed to and enabled me to develop *Southern Gardening* into such a valuable landscape and garden resource. Topics for my weekly column become TV segments, TV segments become social media resources, and social media posts become columns. It is a wonderful and fascinating process learning how the change in presentation impacts different audiences. So I want to say thanks for the dedicated Mississippi State University Extension Office of Agricultural Communications professionals I have the privilege to collaborate with. My main column editor, Bonnie, has been instrumental in bringing this book to fruition; Tim, Jonathan, and Brian for the TV expertise; Amy for producing radio content; and Ellen for her social media prowess.

And finally I want to thank my wife, Katie, who has put up with and encouraged me in my travels around Mississippi to find and share great horticultural tricks, tips, and plants to help home gardeners across Mississippi and the Southeast to be successful and enjoy the benefits and beauty of the home garden and landscape.

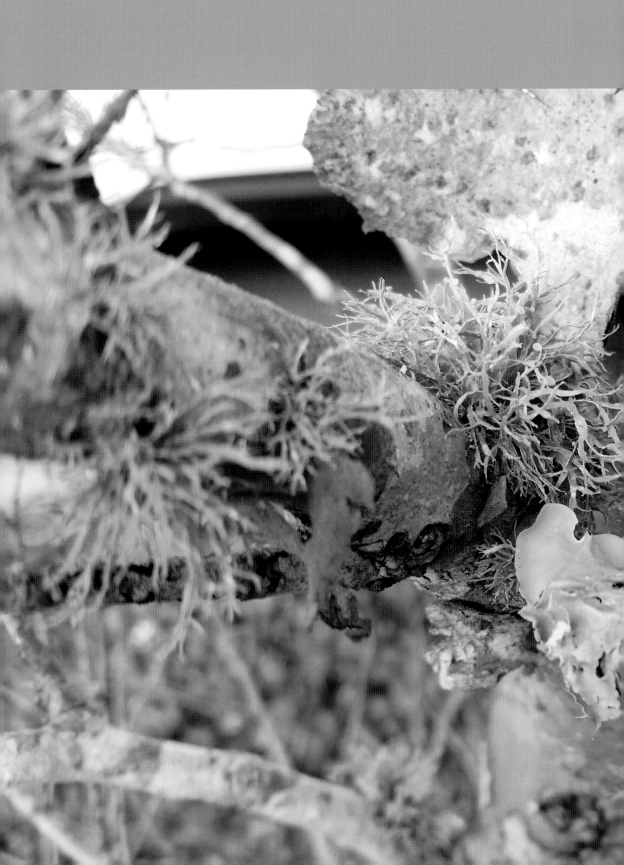

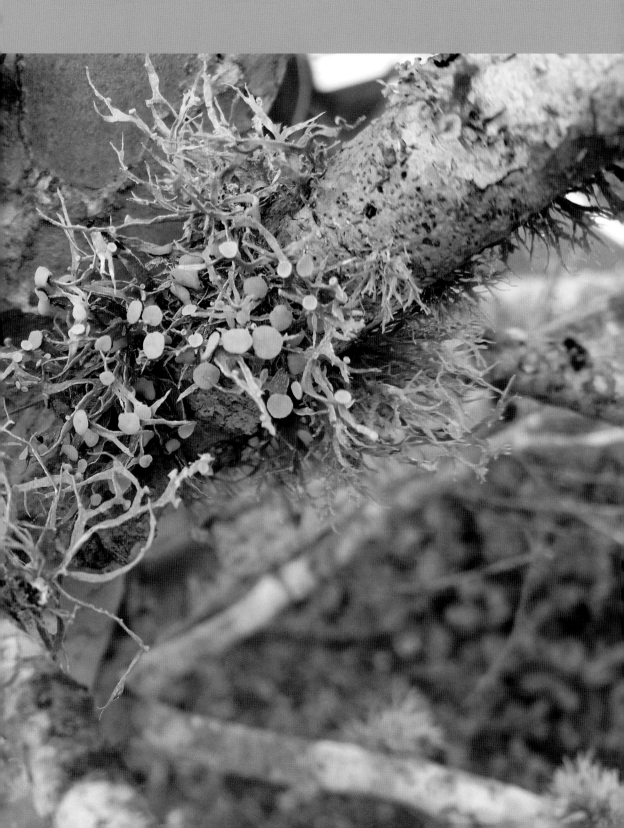

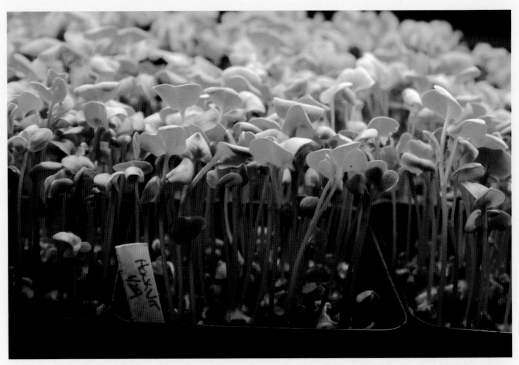

Grow microgreens, such as these Hong Vit radishes, to enjoy winter gardening and keep fresh greens on the table.

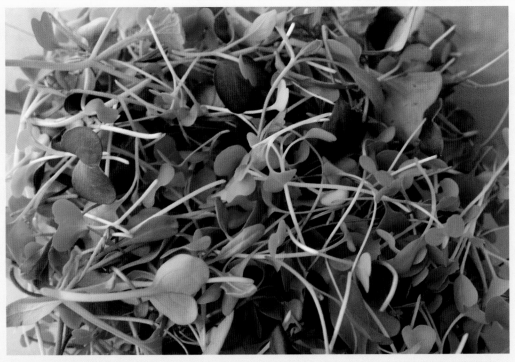

This colorful microgreen mix contains radish, cabbage, and bok choi, all of which can easily be grown indoors during winter months.

Indoor Microgreens Can Stop Winter Blues

Winter can be hard on avid gardeners because cold temperatures prohibit many gardening activities. Gardeners may become bored, restless, and perhaps even show irritation at the slightest annoyance.

These are classic symptoms of gardening cabin fever. For the active gardener, it only gets worse when all those catalogs start arriving.

A simple cure is to bring the garden indoors until spring arrives. Many of those incoming catalogs offer indoor gardening options that border on the extravagant, with fancy grow lights, recirculating pumps, and special growing pods.

But an indoor garden can be as simple as some fresh microgreens growing in a pot on the windowsill. In fact, having a microgreens garden in the winter is the perfect way to satisfy the need to garden and to have delicious and nutritious salads at the same time.

Microgreens are colorful and take as few as seven days to produce a wonderful addition to the dinner table. Asian greens such as bok choi, cole crops such as cabbage or broccoli, or the leaves of carrots, radish, Swiss chard, or beets are often used.

Herbs like basil—the lemon or lime basil selections work quite well indoors—cilantro, and parsley can be grown indoors. Lettuce is not a good choice, as the plants tend to stretch too much when grown indoors.

Growing microgreens is easy and requires only a small space on a windowsill or under a light. Any size container will do. Small containers provide enough to spice up a single dinner or salad. If you use bedding plant flats, you can grow enough to supply fresh microgreens throughout the week.

Always grow your microgreens in a good potting mix marketed for use in containers.

Thickly sprinkle seeds of your favorite greens on the surface of the moistened growing mix. Because the plants are small and you will harvest them after only a short period of time, overcrowding is not a problem.

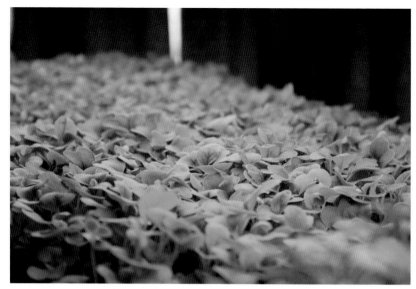

Growing microgreens indoors requires only a small container and a light source.

You actually want your container to be thick and lush with the growing microgreens.

Gently tap the seeds into the soil and cover. A large zip-top plastic bag covers containers well, while a plastic dome is ideal if you are using a bedding plant flat.

The seeds start to germinate after a couple of days, and most greens will be ready to start harvesting after seven days. Some microgreens, such as beets or basil, take 21 days before they are ready to harvest.

Sow seeds weekly to ensure a steady supply of microgreens and to keep you free of cabin fever.

The best way to water your microgreens is to place the container in a saucer, add water to the saucer, and let plants soak up water from the bottom. Because the plants are small, sprinkling water from the top will beat them down.

If you plan to grow more than just a few containers over the winter, consider ordering your seed in bulk quantities to save money. However, buying individual packets from the garden center is a great way to try a variety of microgreens.

So, if you are exhibiting any of the symptoms of gardening cabin fever, try growing some of these fresh microgreens indoors. Not only will you scratch that gardening itch, but you'll have some tasty salads this winter, too.

Bare Branches Bring Attention to Lichens

When funny, mold-looking things start growing on landscape trees and shrubs, phones start ringing in Mississippi State University Extension Service offices across the state.

Winter is a wonderful time of the year when many of our deciduous trees drop their leaves, signaling the end of one year with the promise of new growth in the spring. But it's also the time when home gardeners start to notice other things growing in their gardens. The fact that they are often gray in color can cause dismay in even the most avid gardener.

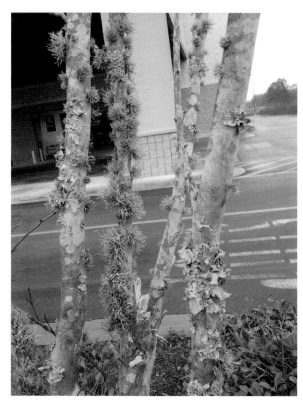

Lichens are an unlikely combination of fungi and algae that survive in a symbiotic relationship.

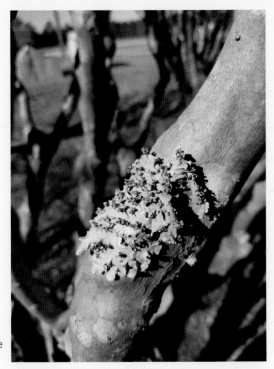

Lichen do not harm trees and shrub but only use the surface of the bark as support.

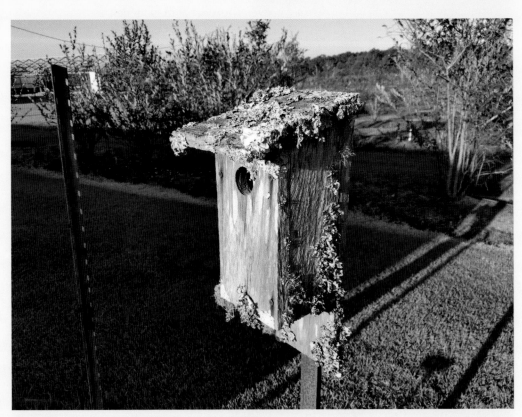

Lichen will grow on any surface, such as rocks, fences, and even mailboxes.

The cause for concern 99 times out of a 100 is something called a lichen. Lichens are very interesting organisms found throughout the world. They are an unlikely combination of fungi and algae that survive in a symbiotic relationship.

Many gardeners incorrectly assume lichens are feeding on the trees and shrubs in some sort of parasitic arrangement. Actually, the lichen is only growing on the surface of the bark. The algae supply food via photosynthesis, while the fungi gather water and other needed nutrients.

Three main types of lichen are found on the bark of woody plants, on rocks, and on other hard surfaces. Some are spreading and have a very flattened appearance. These are the crustose forms of lichen and, as the name suggests, they may look a little crusty.

Other lichens develop folds that resemble a crumpled sheet as they spread across a branch. These wavy folds are produced by foliose lichen.

The third commonly found form of lichen is highly branched with multiple projections. These projections can have a very fine texture that resembles spongy little balls growing on a limb. These are the fruticose forms of lichen.

Lichens are often observed on trees and shrubs that are struggling, and they get most of the blame for the plants' problems. In fact lichen will grow on any hard surface outdoors from wooden fences to rocks and birdhouses. I've seen lichen growing on a satellite dish, a mailbox, and fences.

Most of the time, the lichens were already present before any decline started. Trees that are stressed may lose a few branches, which allows more light into the canopy, and the lichens grow better in the increased sunlight. As a tree continues to decline, lichens continue to grow, giving the illusion that they are causing the problem, when in fact they are just benefiting from the situation.

At this point, you may be wondering what the best way is to control lichen growth. The answer is simply to keep the landscape plants in their best health by following recommended watering, fertilization, and other management practices. A well-growing plant has a canopy that discourages lichen growth.

You can lightly prune damaged branches to encourage new branch growth, which, in turn, helps to establish a denser canopy.

I personally think that lichen adds a touch of patina to our landscape plants, but I know that others have a different opinion. Knowing that they are not harming the plant may give gardeners a new perspective on this unusual thing growing in the landscape.

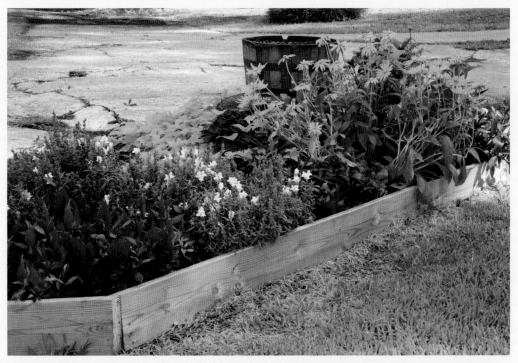

Treated lumber, such as 2- by 6-inch boards, makes constructing raised beds quick, easy, and economical.

Raised beds should be treated like very large containers and filled with soil mixed with organic matter or bagged container media for good drainage.

Raised Beds
Make Gardening Easier

I don't know about you, but, as I've gotten older, the thought of digging up an area of the yard to install a new planting bed has lost its appeal.

Between a bad back and bad knees—not to mention bad elbows, shoulders, and hands—using a tiller to break up soil and adding lots of organic matter is just too much work. Along with the aches and pains, I hope age has made me a little wiser about work and relaxation in the garden and landscape.

My solution to new landscape beds is really an old idea: raised beds.

Mississippi gardeners will find that raised beds offer many advantages. They are easier on our backs and joints, but perhaps the greatest benefit of raised beds is the increased water drainage. Most landscape and garden plant problems I come across in Mississippi are related to poorly draining soil.

Growing plants and flowers in raised beds means the texture of the planting medium remains loose and airy, because it is not being walked upon. Raised beds also allow you to grow vegetables and other plants more densely than in traditional garden or landscape beds.

The construction parameters of raised beds are quite simple. The width of the bed should be no more than four feet. At this width, the longest reach is only two feet, which gives gardeners easy access to the bed from either side.

Sides constructed from hardscape materials will keep the growing medium where it belongs.

The choice of materials is up to the gardener, but I like the newer treated lumber.

If you use lumber, I suggest 2- by 6-inch, 2- by 8-inch or 2- by 10-inch boards, depending on how deep you want the beds to be. A deeper bed gives you more planting options.

Treated pine is produced in a more garden friendly process and is a good choice. Cedar, fir, and redwood have natural resistance to decay

Using stone or brick to contain a raised bed makes a decorative border that keeps the landscape tidy.

if you don't want to use treated lumber. These materials may be more expensive but will last much longer than untreated pine. Other options include using blocks, recycled concrete, or recycled plastic boards.

You could fill the raised bed with native soil, because the height of the bed will greatly improve drainage. But I want you to change your garden paradigm a little bit and treat your new raised bed like a very large container.

I never recommend using only native soil in containers. I like to see a lot of organic matter worked into that soil. In fact, since I don't walk in my raised beds they are filled with commercial bagged container media with a high percentage of peat moss, vermiculite, and perlite. This media remains light, fluffy, and well drained, with excellent porosity.

How much growing media or soil will a new raised bed need? A quick formula to determine the volume of growing media needed is to multiply length by width by depth, all measured in feet. This will give the amount required in cubic feet.

For example, you have a raised bed 6 feet long by 3 feet wide by 8 inches deep. The equation would be: 6 ft x 3 ft x .67 ft (8 inches = .67 ft) = 12 ft3.

This equation works for any raised bed, regardless of dimensions. Whoever thought we would need to use math in the garden?

Daffodils Bring Early Spring Color into Homes and Landscapes

One of the signs that spring will soon be sprung is when the daffodils start awakening and poking up in the landscape beds.

It's something I miss living in south Mississippi, as not too many homeowners plant these wonderful bulbs. But a little north of the coast, daffodil sightings become more common.

When I'm in Starkville in January, and the daffodils that the Mississippi State University main campus is known for are popping, this is a sight to behold. And it's no wonder, with one of the state's largest bulb suppliers located in Meridian.

The variety of daffodils is really astounding. Daffodils are placed in thirteen different divisions or types. I think all of them are gorgeous.

The downside to these wonderful spring-flowering plants is that the foliage begins to look ratty after the flowers are spent. I always field ques-

Daffodils getting ready to burst with bright spring color.

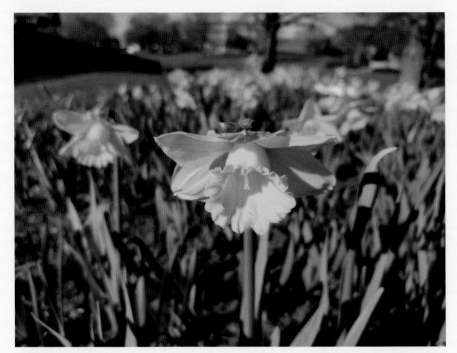

Daffodils are not just for outside gardens like the one shown at the Mississippi State University main campus in Starkville. Forcing bulbs in containers is a good way to bring color into the home during the winter.

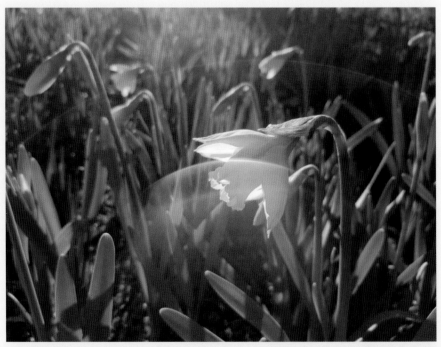

Some gardeners want to clip daffodil foliage. However, the leaves at this stage are producing sugars to store for growth the following year.

tions about what to do at this point. Some want to tidy up the landscape by clipping all the foliage off, clipping it in half, or folding the leaves and wrapping them up with a rubber band.

I tend to be a purist regarding daffodil foliage. My response is always, "Don't touch the daffodil leaves!"

No matter how bad the foliage looks, it plays an important role. Next year's flowers are being formed during this ratty-looking stage. The leaves gather sunlight and, through photosynthesis, store sugars in the bulb for next year's growth. Leave the leaves alone for at least six weeks.

You can tell when the time is right to remove the foliage by gently, and I mean *gently*, tugging on the foliage once a week. The foliage will easily pull up at the right time.

Deadheading—the removal of spent flower heads—is important, as it will maximize the stored sugars in the bulb.

Daffodils are not just for the outside garden. Forcing these bulbs in containers is a good way to bring color and fragrance into the home during the winter. By forced, I mean providing favorable conditions so as to trick the bulb into growing and blooming indoors during the winter months. In fact, many other bulbs species can be forced.

Paper whites are a good choice, as everything the plants need is already in the bulbs waiting to grow. They're so easy to grow that we've probably all seen paper white kits with the bulbs already sprouting.

Other bulb species like tulips, hyacinths, and the popular amaryllis also can be forced.

Place the bulbs on top of decorative rock in a container, without any soil. Add water to just below the surface of the rock. Keep the container in a cool, dark place until the shoots begin to grow. Move it to a warm, sunny spot and enjoy the show.

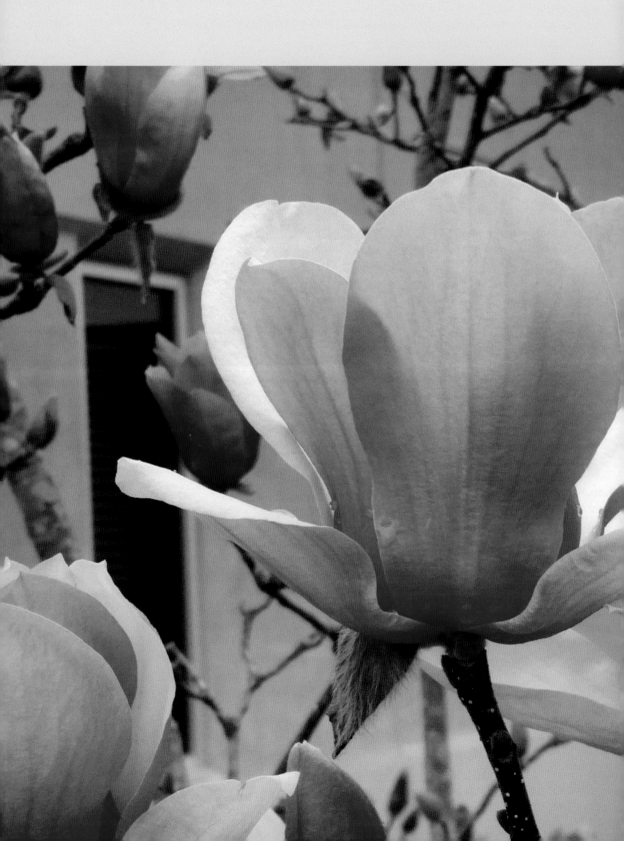

FEBRUARY

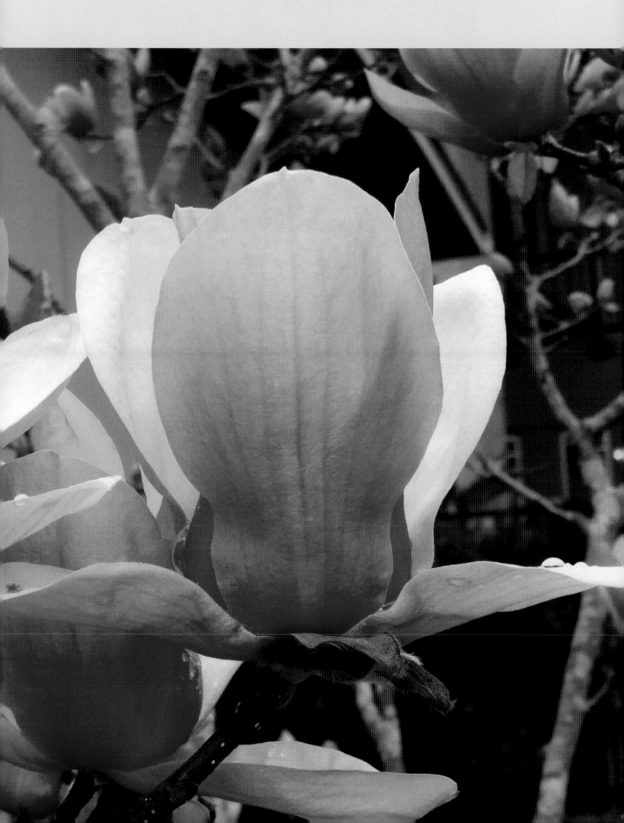

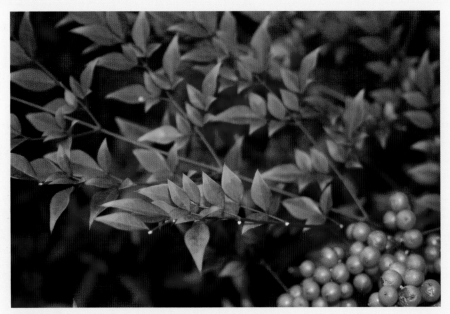

Nandina is a great shrub for providing fall color and berries. The cooler the temperature, the more colorful the plant becomes. Leaves change from bright, glossy green in the summer to a fiery array of reds and burgundies in winter.

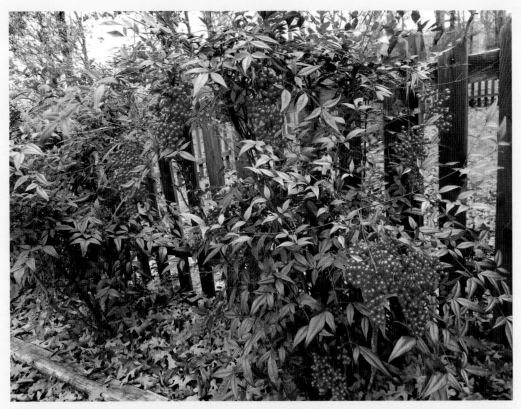

The berries of nandina seem to drip off branches arching from the heavy fruit set.

Plant Nandinas for Great Winter Color and Berries

A lot of great foliage color develops in the cool temperatures of winter months. Japanese cleyera foliage develops a rich burgundy patina that complements its red petioles, and boxwood foliage becomes an orangey bronze.

But my favorite colorful, red-tinged winter foliage must be nandina.

Our grandparents called this plant "heavenly bamboo," and it is known botanically as *Nandina domestica*. Some say this plant is overused in the landscape, but I think they say that because it looks so good. The fact that it has few pests and actually thrives on neglect only adds to its appeal.

The nandina's foliage looks exotic. Leaves are compound and bisected three ways. They are a bright, glossy green in the summer and shine in the winter with a fiery array of reds and burgundies.

Nandina domestica flowers in the spring with big panicles of white. In the fall and winter, the berries are the main event. The clusters of red berries start upright and then hang down from the weight of hefty clusters as the berries mature.

The plant has arching canes that arise from a central-growing crown with bamboo-like canes. If it is not pruned, *Nandina domestica* can grow up to eight feet tall. Control the size easily by pruning the tallest canes. Do this after the berries have set, so you don't remove too many and spoil the winter show.

Dwarf nandina varieties have increased landscape options, but they do not flower consistently and so do not have gorgeous fruit production. Some dwarfs have burgundy and red foliage all through the year, making them a great way to add a splash of red.

In my opinion, one of the best dwarfs is Firepower. Its foliage is green and transforms to red during the cooler months. Foliage color's intensity depends on whether it is planted in full sun or partial shade. The colors are more vivid when the plant gets more sunlight.

Firepower is a great dwarf nandina. Its green foliage transforms to red for the cooler months, with the intensity of the color depending on how much sunlight it gets.

Dwarf nandina varieties look great when planted in masses in the land-scape. They are fantastic in front of large evergreen foundation plantings such as holly or boxwood.

Be sure to buy larger containers when planting these masses. While it may be expensive, you will be more satisfied in the long run. Fewer plants are needed, and they will fill in much quicker for a finished look.

Plant in raised beds in well-drained soil, adding a layer of good-quality organic mulch. Fertilize shrubs lightly each spring with a couple table-spoons of 10-10-10 or slow-release fertilizer. Lightly scratch the fertilizer into the soil surrounding the plant.

Nandina can be divided using a sharp shovel or spade in the winter. Replant immediately or place them in containers for planting at a later date, making sure to water them well while they wait.

Enjoy Early Blooms of Saucer Magnolias

When we have extremely warm weather in the fall and through the winter, many of our flowering landscape plants get really confused. As a result, I've seen fantastic spring displays of color in December and January.

This weather pattern creates a few problems, none of which we can solve as gardeners. We can't control things like a cold snap in February that follows weeks of warm temperatures. When flowers begin to open too early, a quick dip into the low thirties or upper twenties quickly turns them into mush.

I had these worries one year as I watched one of my favorite saucer magnolias beginning to flower just a bit too early. The fuzzy brown buds had been swelling for several weeks, which is normal as the colorful

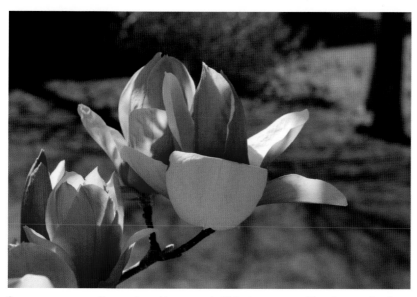

Some saucer magnolias can have blooms up to 10 inches across with colors ranging from white and pink to a bold purple.

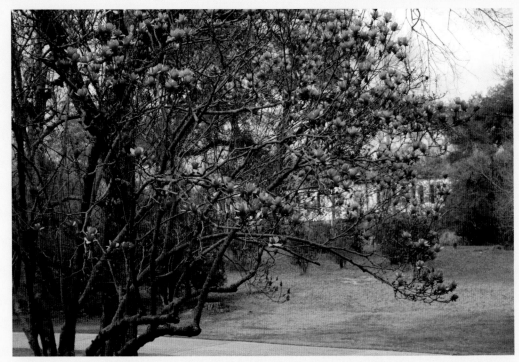

Saucer magnolias are considered small trees, but some can grow quite large. Control the size of the plant by pruning immediately after flowering.

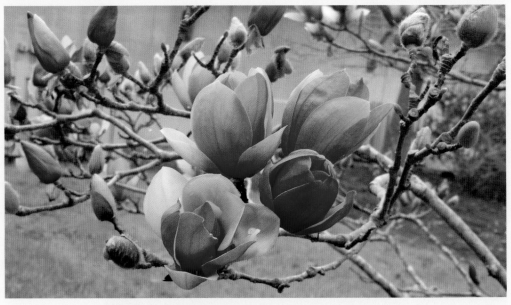

The flowers of saucer magnolia are elegant and chalice shaped just before fully opening.

petals are perfectly protected. But then a little color started peeking out around the edges, and we had upper twenties on the way.

Fortunately, saucer magnolias produce flowers in enormous numbers, and I quickly forgot the few flowers that were nipped once the dazzling pink display got underway.

Some saucer magnolias have blooms up to ten inches across. The colors vary from white to pink and bold purple, depending on the variety. There are many selections and cultivars to choose from, and the decision may be hard to make.

When selecting a saucer magnolia for the landscape, consider the options available. This plant normally blooms in mid- to late spring, usually past the risk of spring frosts. Some selections bloom even later, so, if you're concerned about frosts, just select a late bloomer.

I think the multistemmed specimens are the most attractive.

Saucer magnolia is by far the most popular of the flowering magnolias. It is an old ornamental favorite that is a cross between different deciduous magnolias.

This plant dates back to the 1820s and was brought to North America from Europe. The story goes that the saucer magnolia was developed to bring beauty back to the European landscape after the Napoleonic Wars.

Saucer magnolia is considered a small tree, and it may eventually reach 20 feet tall and wide. While driving around Mississippi, I have seen specimens that have achieved larger sizes, with some of them being larger than some houses.

You can maintain and control the size of the plant by pruning. The best time to prune this spring-flowering tree is immediately after flowering.

The saucer magnolia is a good choice as a low-maintenance, easy-to-care-for plant. There are quite a few named selections; check with your local independent garden center. Be sure to plant yours in full sun in well-drained soil. It's important to make sure the soil doesn't dry out completely, as this causes the saucer magnolia to drop its leaves prematurely. Flower buds also don't develop as well during drought conditions.

Provide a couple of deep irrigations during times of drought stress to help ensure a beautiful spring next year.

Vintage Jade shrub is a refreshing green throughout the year.

The arching and spreading growth habit of Bluescape Distylium looks great in these half-barrel containers.

Distylium Provides a Great Landscape Foundation

F oundation plants have traditionally been planted in the landscape to block from view the raised foundations that many homes have. They enhance the home landscape and help to tie planting beds together. In Mississippi, as well across the Southeast, boxwood, dwarf yaupon holly, juniper, and Indian hawthorn are used as foundation plants as well as for lining walkways and borders.

There is a newer plant on the market that I consider to have *it*, pizzazz, certainly a must-have landscape plant. "It" being thriving in full sun or part shade, and tolerating drought, heat, and wet soil. It also has excellent disease and insect resistance. This plant is one of the 2018 Mississippi Medallion winner introductions, Distylium "Vintage Jade." This is a relatively new plant from a rather unheard-of group of plants.

Distylium Vintage Jade has a compact growing habit with a mounding growth habit. It maintains a dark and glossy green throughout all four seasons. This is the healthy, adaptable, and versatile plant you've been looking for! And perhaps maybe the best aspect of this plant is that it is deer resistant.

This low-maintenance plant is perfect for a smaller landscape space and typically will only grow to three feet tall and four feet wide. I think it looks best leaving this plant unpruned, except for a few wild hairs that might pop out from time to time.

There are other landscape worthy Distyliums available:

Bluescape is a small evergreen shrub with a low mounding growth habit, reaching one to two feet tall and three to four feet wide. Freely branching, clothed in medium to small gray-blue leaves. Small burgundy winter flowers followed by bronze new growth.

Coppertone is a midsized, spreading to rounded, three feet tall by four feet wide evergreen with coppery-red new foliage that matures to blue green. Like all Distylium selections, it produces petite red flowers that appear in the winter.

Distylium is a member of the witch hazel family and produces petite red flowers during the winter months.

Linebacker is an upright, rounded evergreen that will grow to eight feet tall by six feet wide. This growth habit resembles the shape of a white oak whiskey barrel in youth and has the potential to be an excellent screening and hedge plant. Reddish new growth matures to a lustrous dark green.

Distylium are related to witch hazel, and like its witch hazel cousin it produces small red flowers along its stem in late winter, which grow into pretty red berries. These flowers are really a welcome sight when we're in the doldrums of winter, and while not quite as severe as other parts of the country, even Mississippi has the winter doldrums.

As with all shrubs initial planting is important for the ultimate land-scape success. One of the biggest problems I see with newly planted shrubs is planting too deep. The advice I like to give is if the shrub cost five dollars then dig a fifty-dollar hole. I'm not meaning dig it deep; I'm meaning much wider than the root ball. The planting hole should not be deeper than the depth of the root system. Planting this way gives the roots a better chance at growing out into the surrounding landscape bed. In fact I firmly believe the shrub should be sitting a little higher than the surrounding soil. This greatly helps with much of the water-logging condition we commonly see in Mississippi. Planting in raised beds is the best solution.

I like to add a good controlled-release fertilizer into the hole before placing the shrub and backfilling the hole, finishing off with two to three inches of the mulch of your choice. I think with Distylium pine straw would look great.

One final thought, if you're interested in planting Distylium in your landscape be sure to call your local nurseries and garden centers. Distylium is a relatively new plant to the market and not all outlets may have it yet. I know I'll be looking this spring to add it to my landscape.

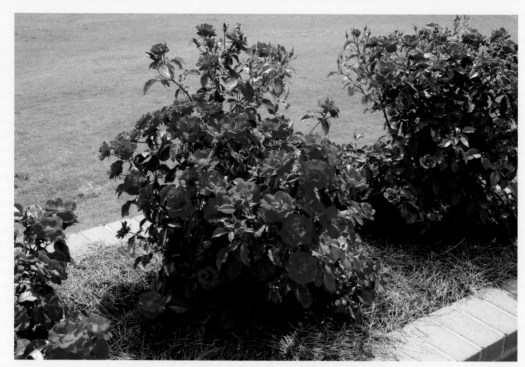

Roses are a beautiful addition to home landscapes, and some modern varieties offer reliable performance without requiring expert care.

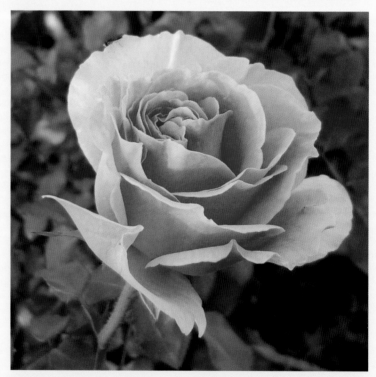

This bloom of Pink Enchantment is a great example of the beautiful flowers produced in the landscape.

Home Gardeners Can Enjoy Garden Roses

Whenever I speak at a rose workshop, I learn that I have had the same experiences and developed the same misperceptions that many home gardeners have with garden roses.

As young homeowners—just for perspective, this story originates forty-six years ago—my wife and I started growing hybrid tea roses in South Carolina. We loved having the fresh-cut stems, but I did not love the maintenance and pest management. So, we stopped growing garden roses.

This attitude persisted even after I became the Southern Gardener.

But Knockout roses came along, and I started to come back around.

After spending time with genuine rose enthusiasts, I'm thinking about adding a few roses to my home landscape in Ocean Springs. Just choosing which selections to add will be a daunting task, as the number on the market is quite broad.

I'm not going to make specific recommendations, but I do want to give you some information about groups of roses for the home gardener to consider.

One group rosarians rave about is the David Austin English rose. I am amazed at how lush the blooms are and how each one is packed with what seems like over one hundred petals per flower. Each flower also has an incredible fragrance.

David Austin roses are a result of an intensive breeding program that crossed fantastic old garden roses with more modern selections. The result is a group of roses that display great growth characteristics with more reliable repeat flowering and a wider range of colors more commonly found in modern roses.

I will have at least one David Austin rose in my landscape this year.

I also learned that efforts to breed disease resistance into beautiful garden roses come with a tradeoff. This breeding often causes the rose to lose its fragrance.

Pink Knockout roses are paired well with Virginia sweet spire.

At Kordes Roses, the breeders' top priorities are disease resistance and fragrance. I was fascinated seeing all the complex flower styles and gorgeous colors they offer. I will have at least one Kordes rose in my landscape this year.

If you are a gardening novice unsure about planting garden roses, the easiest way to enjoy them is to plant Knockout roses. Knockouts are shrub-type roses that are highly disease resistant. They produce flower clusters nonstop in huge numbers. Flower colors range from red to pink and yellow, but I like the red best.

The Knockout rose has multiseason interest.

Foliage in the spring and summer is a dark, glossy green, and fall brings on a deep, maroon-purple show. Always plant in a location that receives at least five hours of full sun a day, with morning sun being the most beneficial.

Another good choice are the Drift series of landscape roses with a spreading habit. They are available in a variety of colors and grow up to three feet tall and four feet wide. They are insect and disease resistant and perform similarly to the Knockout roses.

Once you have a little growing success, I'm sure you'll have more garden roses in your landscape every year.

Add Indian Hawthorn for Spring Flowering

I join the gardening world in waiting for the Southern indica azaleas to officially kick off the spring season with their gaudy show of beautiful color. But there's one landscape shrub that tends to get lost when the azaleas start showing off, and it is actually one of my spring-flowering favorites.

Let me tell you about the Indian hawthorn.

Some gardeners think Indian hawthorn is a ho-hum, no-pizzazz shrub. But this plant is so much more than some of the prima donna shrubs that garner all the attention each spring. An accurate way to describe these shrubs is to say they are hard-working and don't complain much about how they're treated. They are so pedestrian, so blue collar, so reliable!

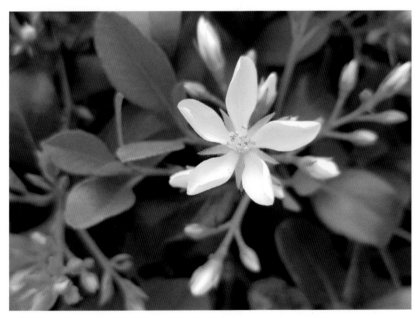

Indian hawthorns produce delicate, star-shaped flowers that range from snow white to light-pastel pink.

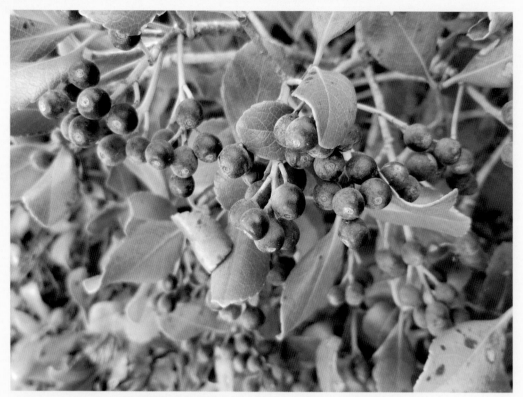

Indian hawthorns produce berries in late summer that ripen in the fall to an attractive blue to black color and persist through the winter months.

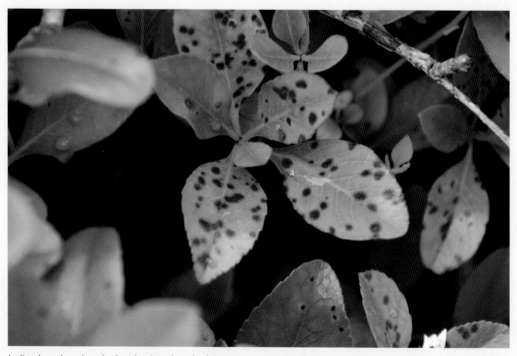

Indian hawthorn's only drawback is that the foliage is susceptible to Entomosporium leaf spot.

But when you actually look for them, you'll find Indian hawthorns are in almost every south Mississippi landscape as foundation anchor shrubs. That's because they're reliable, and every home gardener wants reliability in their landscape.

The Indian Hawthorn is the perfect evergreen shrub to plant in your home landscape in hardiness zones 7a through 10.

Star-shaped flowers ranging from snow white to light-pastel pink emerge in the spring in clusters held loosely at the ends of branches.

On calm spring days, you may catch a hint of their delicate floral fragrance when you stroll by a hedge in bloom. The pistil and stamens are reddish, matching the color of the newly unfolding foliage. This feature adds additional interest and contrast to the flower color.

Indian hawthorn is not just a hard-working spring shrub. It also gets the job done in the summer and fall.

Thick and leathery evergreen foliage provides a fantastic backdrop for warm-season annual color. The top of the foliage is a lustrous dark green in the summer, and it can turn a purplish blue-green when exposed to winter temperatures. The leaf margins have soft, serrated edges that are highly variable.

This shrub's only real problem is that the foliage is susceptible to Entomosporium leaf spot.

Gardeners can take some of the blame because we like to mass-plant Indian hawthorn. Preventive sprays with fungicides containing chlorothalonil or propiconazole can help in the spring and fall. The pathogen survives in leaf litter, so it is a good idea to clean up the fallen leaves from around the plants to help prevent the spread of this disease.

In the fall, Indian hawthorns produce fruit that are an attractive blue to black color. They ripen in late summer and fall and persist through the winter.

Plant Indian hawthorn in full sun to partial shade. It prefers a consistently moist but well-drained landscape bed. To help ensure adequate drainage, plant the crown one or two inches above the soil level for the best landscape performance.

Indian hawthorn tolerates pruning especially well, making it is easy to keep it less than three feet tall in the landscape.

So, if your landscape needs a boost from spring-blooming shrubs, consider Indian hawthorn selections when you go shopping at the local garden center.

MARCH

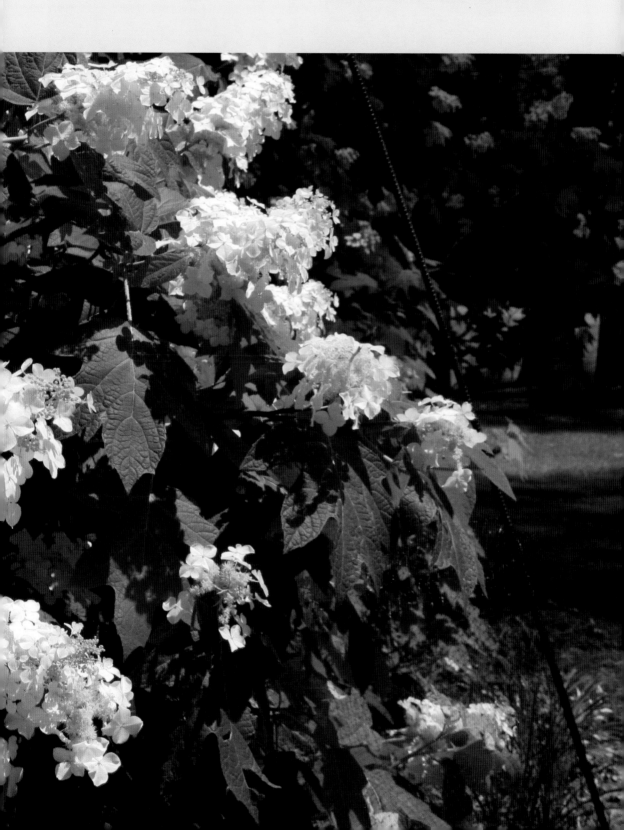

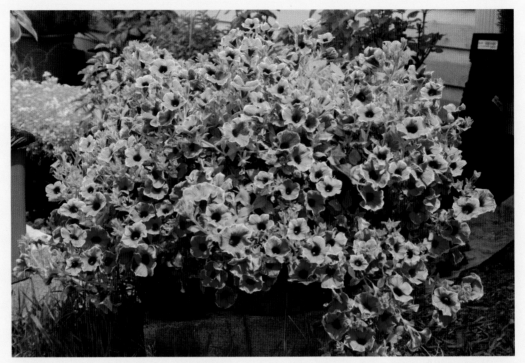

Supertunias are big, bold, and free-flowering plants ideal for summer blooms. They come in a variety of colors, including this Pretty Much Picasso Supertunia.

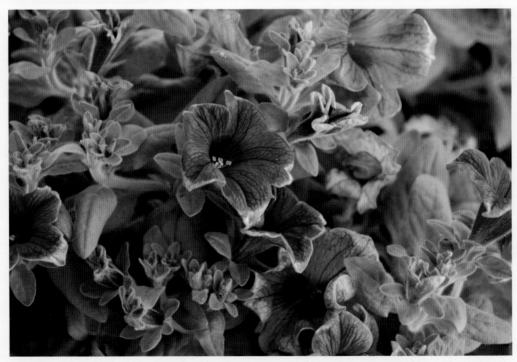

The Picasso Supertunias have variegated foliage and two-tone flowers. This Picasso in Blue is a new addition to the Supertunia line.

Use Picasso Supertunias in Summer Landscapes

As I walked around my landscape this weekend, I was really impressed with how my three winter staples—pansies, violas, and Telstar dianthuses—are enjoying the lengthening days and a little bit of warmer weather.

They are blooming like crazy, almost in response to what I've been thinking: It's time to start planning and planting warm-season annuals.

These seasonal transition times are tough.

My neighbors always ask, "Gary, why are you pulling those flowers out when they look so good?" It's not because I'm mean or don't like the flowers. I like to get most of the summer color in the ground early to allow the plants time to establish a good root system before temperatures get too high.

There are plants, such as annual vinca, that shouldn't be planted until the season really warms up, so trust your nursery professional's advice when plant shopping if you have any questions.

Getting back to my summer landscape color: if I could use only one plant type, I would choose the petunia, or, more specifically, Supertunia. In my opinion, you can't go wrong with these plants.

Supertunias are big, bold, free-flowering, and self-cleaning, so no deadheading is required. The selection of colors available allows you to work with any color scheme.

One of my favorites is the Mississippi Medallion winner Vista Bubblegum, with its clear-pink flowers and three-foot or more spread.

But the Supertunia varieties I'm really impressed with are the Picassos. This may be because I like variegated foliage, and I'm impressed with two-tone flowers. They all have an outer edge of petals ringed in green that tends to blend in with the foliage and allow the artistically painted flowers to stand out.

Pretty Much Picasso has grown well in my garden. It's the flower color scheme that really impresses me. This plant has unique pink petals with a purplish throat. The flower edges are lime green and tend to

Supertunia flower edges are lime green and tend to blend into the foliage, allowing the artistically painted flowers to stand out like this Picasso in Pink.

blend into the foliage, making it difficult to see where the flower ends and the foliage begins.

Newer additions have been Picasso in Pink (green and pink flowers) and Picasso in Blue (green and purplish-blue flowers).

The newest creation available beginning in 2016 was Picasso in Burgundy. I had the opportunity to trial these in my home garden last year, and they were truly outstanding.

Always plant in full sun for the best flowering and growth.

Keep the soil or potting medium consistently moist. Letting the plants dry out and start to wilt will shut off the flowering for up to a few weeks. Proper watering is especially important when these flowers are grown in containers, as they dry out much faster than when planted in the ground.

Early morning watering helps keep the soil moist. During the hottest months, you may need to water containers and hanging baskets again in the afternoon. This is where having a drip irrigation system is very useful.

All Supertunias are heavy feeders, so apply a controlled-release fertilizer at planting. For the best growth and flower production, feed these plants on a regular basis. I prefer using a water-soluble fertilizer once a week when I water the plants.

These great plants are butterfly and hummingbird magnets, so be sure to plant some in your landscape and garden this and every year.

Native Redbud Shows Out with Bright Spring Colors

One of my favorite spring flowering trees is our native redbud. This small tree flowers early in the spring before most other trees have started to leaf out after their winter naps. It's good that redbuds bloom so early, because they are usually found as understory trees. While driving around the state, it's common to see a redbud framed or silhouetted by leafless hardwoods.

The redbud is a readily adaptable species that can tolerate many different soil and climatic conditions. It is fairly uncommon in the coastal counties, where most redbuds are planted as part of an ornamental landscape.

Redbuds are much more common north of a line drawn through Hattiesburg. First, you'll spot native redbuds growing in the swales around creeks. As you move north, they become more common on flatter land. One of my favorite individual trees stands alone at the back of a field along Highway 45 north of Meridian.

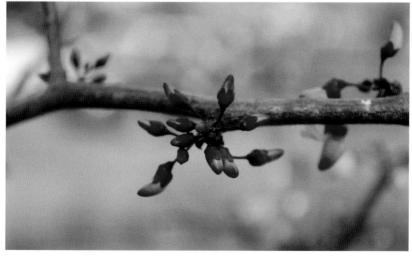

Redbud flowers bloom in clusters held tightly against stems and branches. The outer layer of bud scales protecting the developing flower are deep red, giving the plant its name.

Native redbuds are small understory trees that bloom before most trees put on leaves. This specimen stands alone off Highway 45 north of Meridian.

Mississippi State University's campus has many examples of the Forest Pansy redbud, which has gorgeous heart-shaped, purple-maroon foliage.

The flowers are gorgeous in the spring. Their color ranges from light, clear pink to purplish pink, and there are even several white-flowered selections in the nursery trade. The flowers are grouped in clusters held tightly against the stems and branches; a pattern called cauliflorous flowering.

The colorful flowers along the stems and branches outline the branching structure of the tree. If you use your imagination, you'll see various shapes, much like watching clouds. In fact, these trees resemble pink clouds from a distance.

The individual flowers closely resemble pea flowers, and, believe it or not, the flowers actually taste like peas.

This fact isn't too surprising, as redbud is a member of the legume family and even produces flat brown seedpods.

When grown under optimal conditions, redbud is considered a small tree with the potential of reaching fifteen to thirty feet tall. The general tree form has a short trunk and a rounded, almost umbrella-like crown.

Foliage emerges after the flowering is finished, almost as if the leaves don't want to interfere with the pink show. Leaves are heart-shaped and can be three to five inches across. They are glossy green in the summer.

For best growth, consider redbuds to be understory trees. Planting sites with partial to full shade are probably the best, but I can think of several redbuds growing out in the full sun that are splendid specimens.

I really like the selections with maroon-colored leaves. The color is so close to Bulldog maroon that they are planted all around the main Mississippi State University campus. One of the best selections I would pick for the landscape is Forest Pansy. This selection has heart-shaped, purple-maroon foliage with outstanding color when it receives morning sun.

A question I've received concerns the flower color of redbud: "If the flowers are pink, why is it called redbud?" If you look at the flower buds before they begin to open, the origin of the name is apparent. The outer layer of bud scales protecting the developing flower are a deep red, hence "redbud"—not "pink flower."

Enjoy redbud's color show this spring and consider planting this native species in your landscape.

Molten Lava oxalis has beautiful yellow, orange, and burgundy foliage and shows off bright yellow flowers all summer.

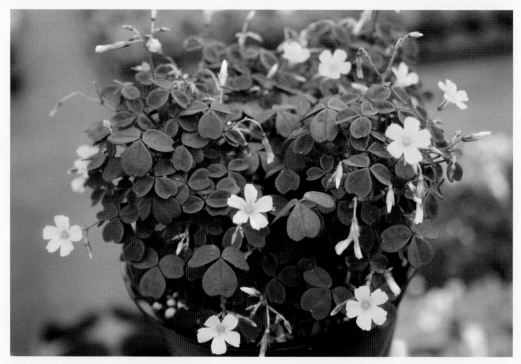

The flowers may be dainty, but the yellow blossoms shine brightly with the dark purple/black foliage background of this Zinfandel shamrock.

Mississippians Find Luck
with Shamrocks

St. Patrick's Day is a great reason for bringing home a three-leafed shamrock from the garden center. In addition to the traditional green, more and more varieties are showing up with gorgeous purple to almost black foliage.

The Charmed series offers Velvet and Wine varieties, both with black/purple foliage and pink flowers. During the summer months, place shamrocks outside in full shade, as the sun will bleach the leaves. These plants reach 12 to 16 inches tall and wide.

Velvet and Wine make good planting partners in shade containers. As filler plants, they mingle and poke out between the other plants in the container.

Shamrocks, sometimes called clovers, are part of the oxalis family. They make great houseplants, but there are some outstanding oxalis selections for the landscape.

These are sterile and noninvasive landscape varieties and not the weedy scourges we battle each year. Known botanically as *Oxalis vulcanicola*, these landscape oxalises grow about six inches tall and have a spreading habit of a foot or greater. They can be planted in full to partial sun.

Zinfandel is a purple-black selection with bright yellow flowers, but my favorite shamrock is Molten Lava. The foliage is primarily chartreuse when planted in partial shade, but, in full sun, it lives up to its name. It becomes a bright lime tinged with fiery yellow-orange.

You might want to label these in your landscape, as they do look like the weedy species of oxalis. Labels will stop someone from thinking they are doing you a favor by pulling them up.

In Mississippi, we do have a little, naturalized nonnative oxalis called cottage pink wood sorrel, or *Oxalis crassipes*. I always enjoy seeing these cheery, clear pink flowers randomly popping up in my landscape and garden. They bloom much of the summer in a shady part of my yard.

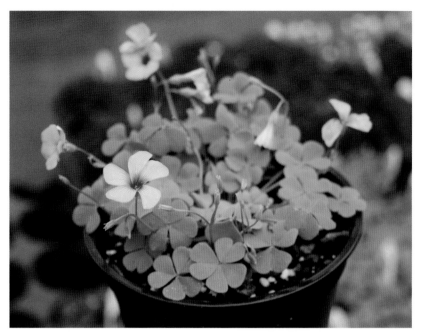

Plant these dark green shamrocks in containers or in the landscape and enjoy the pink flowers that highlight Cottage Pink oxalis.

In full sun, the blossoms are spring visitors that go to sleep in the summer when the temperatures get too high, then awaken when cooler weather returns the next spring.

Once established, oxalis species are drought-tolerant when grown in the landscape. In containers, they need to be watered.

So why are shamrocks and oxalis associated with St. Patrick's Day? According to legend, Patrick returned to Ireland to spread the gospel of the Holy Trinity, but the congregations were having difficulty understanding the concept. He went to the garden and selected a three-leafed shamrock to show the three leaflets on one leaf.

While they normally have three leaves, sometimes there is a mutation that produces a fourth leaf. Finding the rare four-leafed clover was considered an omen of good fortune by the ancient Celtic people. Children still spend enjoyable summer afternoons looking through patches of clover for that lucky four-leafed clover.

So, try some of these oxalis—they just may turn out to be a good-luck charm in your garden and landscape this year.

Oakleaf Hydrangeas Bring Early Spring Flowers and Color

The signs are all around us.

Red maples and redbuds are flowering, and yellow jessamine is scrambling and blooming along fences and way up in trees. Low winter temperatures have the ornamental pears really putting on a show.

Daylight Savings Time has kicked in, and we're almost to the spring equinox. This can only mean one thing: Warmer weather has to show up sometime in the near future.

Flowering shrubs will soon take their turn brightening our gardens and landscape. Nothing can beat the show the Southern Indica azaleas put on. But there is one flowering shrub I look forward to more than others each year, and that is the oakleaf hydrangea.

This shrub is a tough native plant that gets its common name from leaves shaped like oak leaves.

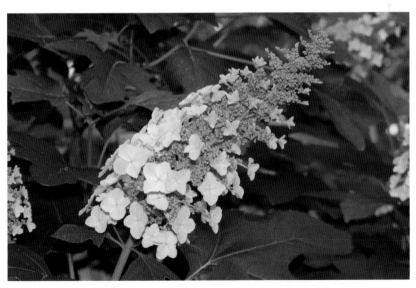

Oakleaf hydrangea flowers are clusters made up of smaller, individual flowers growing in a cone shape. They start white and transition to pink shades.

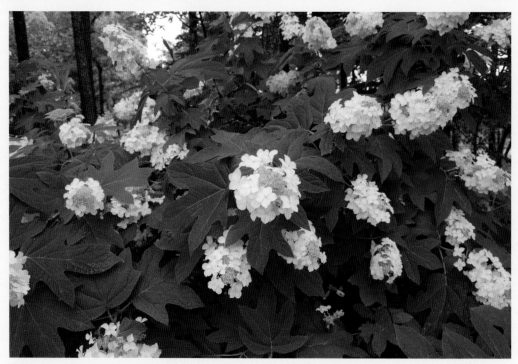

Oakleaf hydrangeas bloom from early May to the middle of June. The coarse-textured foliage provides an excellent background for later-flowering plants, and it turns from dark gray-green to bronzy reds, oranges, and browns in the fall.

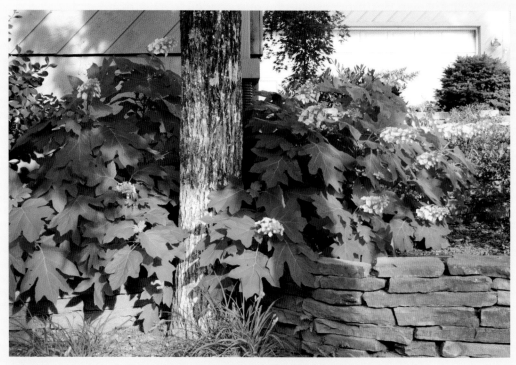

Oakleaf hydrangea is a perfect choice for the partial sun at the edge of a rustic planting bed.

In Mississippi, oakleaf hydrangeas start blooming in early May and continue through the middle of June. If you've traveled east along Interstate 20 from Jackson you've probably seen the white flowers blooming along the woodland hillsides just outside of Vicksburg.

The flowers are actually made up of many smaller, individual flowers growing in cone-shaped clusters that can be up to a foot long.

The showy, four-petal flowers are infertile and attract pollinators (and gardeners). The petals open snow-white and transition to shades of pink. The fertile flowers are inconspicuous in the flower clusters.

In 2000, Snowflake was selected as a Mississippi Medallion winner. The double flowers of this plant are excellent as cut flowers and can be collected for use in dried arrangements.

The coarse-textured foliage provides an excellent background for other plants that flower later in the summer gardening season. The foliage is a dark gray-green and has fall colors ranging from bronzy reds to oranges and browns.

This is a deciduous shrub, and, after the leaves drop in the fall, the upright branches expose exfoliating outer bark and cinnamon-tinged inner bark.

Oakleaf hydrangeas can be used as mass plantings. Plant them seven to eight feet apart to allow their natural shape and form to develop. Oakleaf hydrangeas are also fantastic specimens in the landscape, and they grow well in containers on the patio or porch.

Oakleaf hydrangeas grow best in well-drained, highly organic soils. Dig the planting hole twice as wide as the root ball, and mix good, aged compost with the soil from the hole. Set the plant only as deep as it was in the container.

Current research shows that planting the crown a little higher than the surrounding soil improves drainage. Fill in the hole with amended soil and mulch with two to three inches of good organic mulch.

These hydrangeas perform best when planted in at least partial shade or filtered light from overhead trees. Consistent moisture is a must but avoid overwatering at all costs. Oakleaf hydrangea tolerates pruning. Remove the tallest and any wayward branches by pruning at the base.

Use a good, slow-release fertilizer such as 14-14-14 for best results. Depending on plant size, spread one-half to one cup of the fertilizer around the plants in late March or the beginning of April to keep your oakleaf hydrangeas thriving.

APRIL

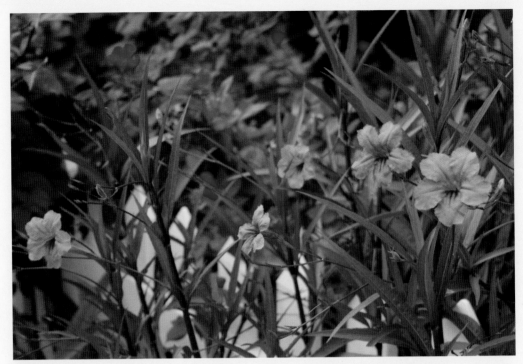

The bluish-purple, trumpet-shaped flowers of the Ruellia, or Mexican petunia, resemble azaleas when massed together.

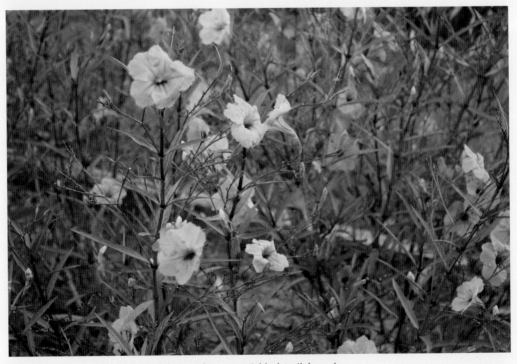

Mayan Purple is a newer selection that produces nonviable (sterile) seed.

The Case of the Missing Blue Mexican Petunia

The story you are about to read is true. Only the names have been changed to protect the innocent.

It was a spring morning several years ago, just like this morning, when I received the call. I thought it was going to be like many others I receive. I was wrong.

The person on the other end of the phone had a neighbor's cousin visit the coast some years ago but wasn't sure about the season. While at a local golf course, they had spotted a blue azalea, and now the caller wanted one.

A missing plant report. This is south Mississippi. My name is Bachman. I'm an Extension agent.

I was intrigued with the call, as there aren't too many blue azaleas around. I went to the golf course to nose around. I figured it was spring, and this would solve this case quickly. There were lots of gorgeous southern Indica azaleas blooming. The bright magenta flowers of Formosa were outstanding. But there were no blue azaleas.

The trail went cold.

In late summer, I had a hunch and reopened the missing plant file. When I returned to the golf course, it became clear that this was a case of mistaken identity.

Many of the homes bordering the fairways had plants with gorgeous bluish-purple, trumpet-shaped flowers. When massed together, these plants did indeed resemble azaleas.

Taking into consideration that the caller had been zipping around in those fun little golf carts and had surely been distracted by beautiful girls driving the beverage and snack carts, it's easy to understand the plant confusion.

I wasn't looking for the rare blue azalea but the much more common Ruellia, which often goes by the alias "Mexican petunia."

I know this plant because, in the summer and fall, they can put on a flowering show.

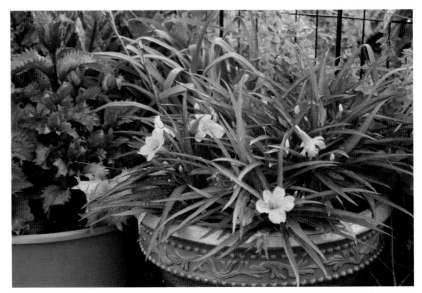

Dwarf varieties of the Mexican petunia such as this Ruellia Katie Dwarf come with bluish-purple, pink, or white flowers.

Mexican petunia is perfectly suited to high temperatures and frequent dry conditions. Although each flower is open for only a single day, plants produce what seems to be an unlimited number of flower buds. In full sun, the trumpet-shaped flowers are held proudly for all to see.

Many novice gardeners plant the full-sized Mexican petunia because it is an easy, low-maintenance plant. I like not having to deadhead the spent flowers. But take care, because this plant is fairly aggressive in a well-prepared landscape bed. It spreads via rhizomes, which are under-ground stems, and its prodigious amount of seeds. With only a little encouragement, this plant can become a weedy problem. The good news is there have been efforts to breed sterile selections that would eliminate the weedy problem. The Mayan series of purple, pink, and white ruellia would be good choices.

The dwarf Mexican petunia has a variety of disguises, with flowers of bluish-purple, pink, and white. Dwarf varieties bloom all summer when the soil is consistently moist.

When I closed out the missing plant report, I told the caller how dwarf selections available at garden centers and nurseries are not aggressive but still have beautiful flowers. These grow only to about six to eight inches tall and are perfect for containers.

Since I have these flowers in my own landscape, I could have solved the case sooner had I not been focused on finding a blue azalea.

On the coast, they overwinter fine without additional protection, but they require a good layer of mulch in the fall to survive in more northern gardens and landscapes.

Grow Pinks for an Easy, Pretty Garden

When a plant with pretty flowers is advertised as easy to grow, it always catches the gardener's eye. While many plants may not live up to this billing, pinks really deliver in the landscape.

You can call them cottage, cheddar, or just plain pinks, but this group in the *Dianthus* genus are composed of several species and hybrids. Pinks are close relatives of the florist carnation and the wildflower Sweet William.

Even though they are called pinks, flower colors include white, lavender, red, and pink. They have a nice variety of flower types, with single and double flowers and serrated and fringed margins. Their grass-like foliage ranges from bright green to blue gray. And did I mention that many have a spicy clove-like fragrance?

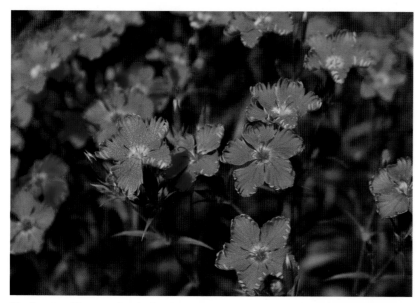

The flowers of Bouquet Purple dianthus are a vivid, dark pink with petals having tattered, upturned margins.

The stems of Bouquet Purple are up to 18 inches long, making these a great choice for cut flowers.

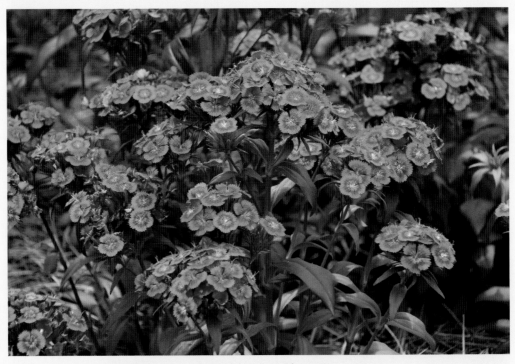

Jolt dianthus have a great landscape presence with long stems for cutting.

Pinks can be from 3 to 24 inches tall and up to 24 inches wide. The smaller varieties have tight, formal growth habits. These are perfect for a rock garden or for straight lines and square corners in a formal design. Try cheddar pink varieties Tiny Rubies or Bath's Pink.

The taller varieties are looser and have a more casual style. The 2001 Mississippi Medallion plant Bouquet Purple dianthus is perfect for the cottage garden. The flowers are a bright, hot pink purple on stems up to 24 inches long. This is a good cut-flower producer that will rebloom.

Other reblooming varieties include cheddar pink Firewitch, maiden pink Confetti Cherry Red, and the Jolt mix.

Deadhead your pinks after flowering. The easiest way is to simply hold a bunch in one hand and use your pruners or scissors to reduce by half. The plants will put out new growth, and reblooming varieties will give you a quick encore.

Pinks have a reputation for being short lived, but this usually happens when there is excessive soil moisture that causes the center of the plant to brown-out. To prevent this problem, always plant the crown slightly above the normal soil level so it stays dry. This advice is for both in-ground and container-grown pinks.

Try this recipe to improve drainage in a heavy clay soil. Mix one-third of the soil removed from the hole, one-third poultry grit (a finely crushed granite) or horticultural perlite, and one-third compost. The new, coarse soil texture allows water to drain away from the plant crown.

Try a combination planting of pinks with bugleweed, blue fescue, coral bells, and stonecrop for a truly easy-care landscape bed.

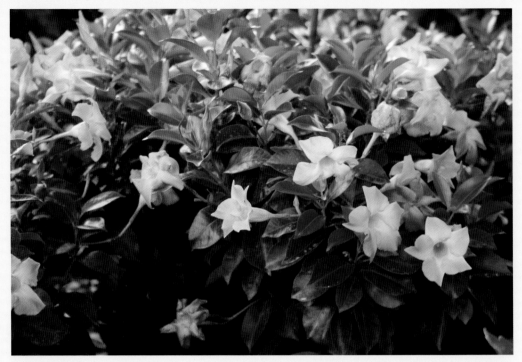

Mandevilla flowers are displayed against dark green, leathery foliage. Mandevilla blooms from early summer through first frost.

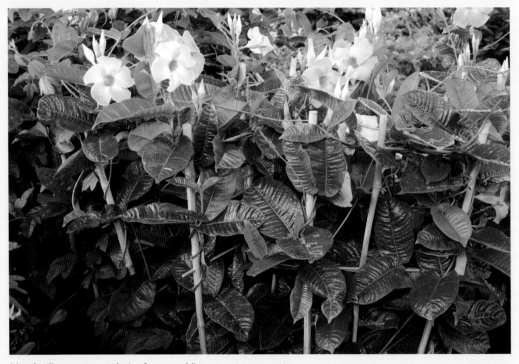

Mandevilla are a great choice for scrambling up onto supports.

Mandevilla Vines Give Gardening Possibilities

If you're thinking about what you want your porch or deck to look like this summer, consider how you can use Mandevilla, a vining plant best known for its showy displays of summertime flowers.

You can find these plants in red, pink, and white at garden centers. Flowers are displayed against a backdrop of dark green, leathery foliage. Leaves can be quite large—up to eight inches across. Some selections have smaller leaves. The plants are sometimes confused with Dipladenia, which rhymes with gardenia, and is similar flowering but with a bushy, nonvining habit. I've been fooled in the past, so be sure to read the label.

Flowering begins in the early summer and continues through frost in the fall. Mandevilla is considered a tender plant that requires protection when temperatures fall below 40 degrees. This plant is hardy through zone 9, which is good news in the coastal counties.

Mandevilla is usually killed back by fall frosts, but in mild winters it may grow back from the root system the following spring. Most gardeners simply treat Mandevilla as a flowering annual.

This vine grows and flowers best when planted in full sun. It tolerates partial shade in hot locations, such as south-facing walls. Make sure the soil in the planting bed is rich with organic matter to ensure good drainage, but don't let the soil dry out too much.

While Mandevilla can tolerate some droughty conditions, it requires supplemental irrigation for extended periods of drought.

Mandevilla is a great choice for growing in containers on the porch or patio.

This is a popular planting method in areas with cold winters. When the cold winds start to blow, gardeners simply bring the container inside for protection. If placed in a window with enough light, it makes a fine houseplant for the winter months.

Because Mandevilla is a vining plant, you must provide support for the plant to scramble and climb. You can make your own supports from hard-

ware cloth, plastic mesh, or other materials that give the plants a surface to climb. You can hang the mesh between two stakes for a simple design.

If you want something more elaborate, design a trellis from thin strips of wood secured in a vertical and horizontal crisscross pattern. If you don't provide support, Mandevilla could turn into an odd ground cover.

Mandevilla is very tolerant of pruning. With careful pruning, you can train the plant to grow in a shrub-like form. Flowers are produced on new growth, so there is little worry about pruning too much and removing the season's blooms.

Mandevilla is a fast-flowering vine that can quickly cover a garden with beautiful, colorful flowers or mask an ugly area in your landscape.

Plant Colorful Salvias for Color, Pollinators

I'm becoming a fan of salvias for their performance in the landscape. This group of plants has such a wide variety of selections available from annuals to perennials that I'm sure you can find the perfect plant for your garden. Today, I want to tell you about the salvias I'm growing in my own home landscape.

Rockin' Playin' the Blues salvia is a selection I've grown as a trial plant, and it hasn't disappointed. The plant produced beautiful blue flowers all summer long.

A nice feature is that the plant is sterile, which means none of its gorgeous flowers produce seed that could become a weedy problem. I like

Rockin' Playin' the Blues is a new salvia that produces beautiful blue flowers all summer long without reseeding and becoming weedy.

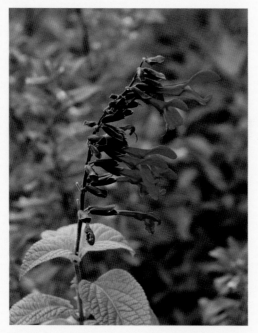

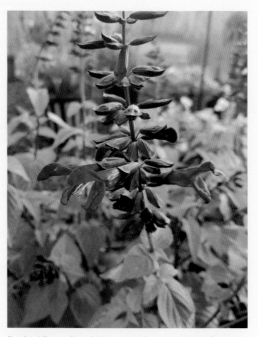

The Black and Bloom salvia has large, deep-blue flowers that bloom early in spring on black stems with dark leaves.

Rockin' Deep Purple has nice deep, dark purple flowers that provide a great color contrast to the black stems.

Wendy's Wish salvia is a tough plant that thrives in hot and humid summers with vivid, magenta-pink flowers and maroon stems.

the fact that the blue calyx—or cup-like outermost floral parts—remains after the actual flower falls off, giving the color an even longer-lasting landscape effect.

I also enjoy watching bumblebees and other pollinators feast on the nectar-filled flowers.

Another favorite is Black and Bloom, a perennial in my Ocean Springs landscape that I have growing in a 15-gallon container. Its large flowers are often among the earliest to bloom. The plant has dark leaves and black stems and calyces, which seem to accentuate its deep-blue flowers. I really like the contrast between the black and blue.

A similar selection that I'm growing this year, and hopefully in years to come, is Rockin' Deep Purple salvia. It's reminiscent of Black and Bloom, except the flowers are a nice deep, dark purple. This is another example of a great color contrast between the purple flowers and black calyces and stems.

Regular watering and fertilization keep the root zone consistently moist and the plant growing and showing off strongly.

Rounding out my favorite summer salvia is Wendy's Wish.

The vivid, magenta-pink color of this tubular flower coupled with the reddish-pink calyx is gorgeous. The flower stems are maroon and arranged in an open structure. The plants grow in clumps. This is a tough plant that thrives in our hot and humid summers. It is also a favorite plant of hummingbirds by day and hummingbird moths around sunrise and sunset.

I take measures to make sure my salvias perform at their best. I've found that they perform fantastically in containers that give them increased drainage.

I transplant mine into 15-gallon nursery containers. These pots are bigger than your normal container, but my plants respond accordingly. Large containers give the root systems plenty of room to spread out, and they make it easier to maintain a consistent root zone moisture for optimum growth during the summer.

If you grow your salvia in full sun with consistent moisture and good drainage, I know you'll enjoy these plants in your garden as I do in mine.

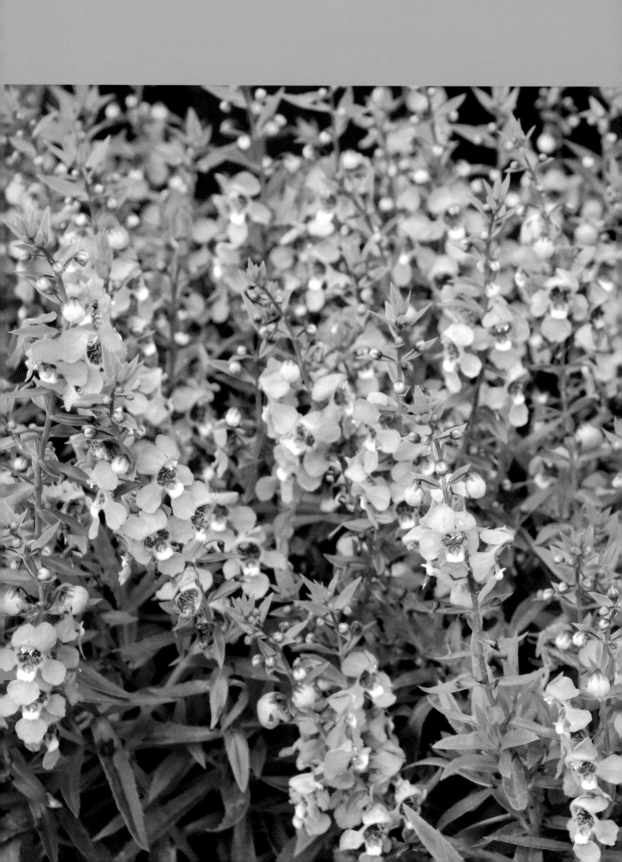

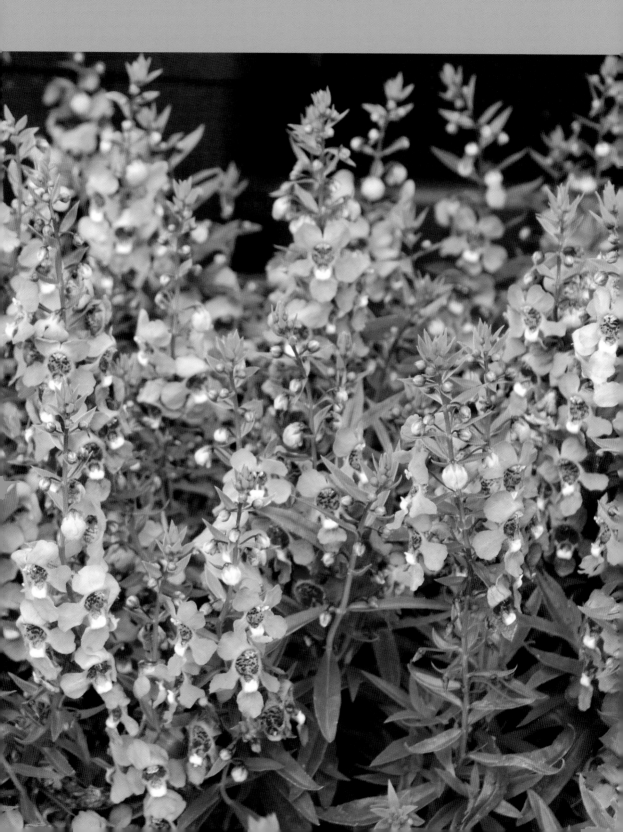

MAY

It takes special plants to find gardening success in the hard-to-handle strip of land between pavement and sidewalk. This Pizzazz tangerine purslane combines well with New Look celosia.

Purslane, like this Pizzazz yellow, is a succulent that thrives in high summer temperatures.

Be Creative and Persistent in Tough Garden Areas

If there's one area in almost everyone's landscape that causes a lot of problems, it's that area between the sidewalk and the street.

I surrounded my mailbox with a small planting bed to help me try to garden in this area. I have had some success trying many different planting combinations that change with the seasons. But it's the summer that causes me the most trouble.

The conditions in this area that cause gardening angst are many, and they build upon each other.

Summer soil temperatures skyrocket from the reflective heat radiating off paving materials on both sides, and this really bakes the planting bed. Weeds thrive, despite the harsh conditions.

I have particular trouble with the combination of green kyllinga, nut-sedge, and Virginia buttonweed. Watering is problematic, because the area is sloped to the street for drainage, which makes it hard to irrigate the bed.

It's no wonder that professional horticulturists and homeowners alike call this area the "hell strip." If you have an area like this that causes you heartburn, I'd like to share a couple of plant selections that have done well for me in my personal hell strip.

Purslane, a really old plant, is one that I have used. It's a succulent that thrives in high summer temperatures. Purslane has long been regarded by many as a garden weed, and I have removed many of these plants from my garden and landscape.

However, purslane's summer-loving qualities make the improved selections perfect for the landscape. Purslane is a larger and more robust version of its relative, the popular bedding plant moss rose.

Pizzazz purslanes are low-growing, succulent-looking annuals that are available in a variety of colors. The stems are purplish-green, and the leaves are bright green. They grow up to 8 inches tall and spread to 18

Gold Dust mercardonia is a tough annual that can handle the difficult area between sidewalks and roads. With irrigation, it can create a blanket of yellow flowers.

inches, so space them 12 to 15 inches apart in the landscape. Regularly pinch off branches to keep purslanes dense and full.

Purslanes are heavy feeders that require adequate nutrition throughout the season for best flowering and growth. The flowers close on cloudy days and when the plant is under stress. They have been observed to close in late afternoon and early evening, as well.

The other plant that really surprised me last year with its performance in this tough spot was the annual Gold Dust mercardonia.

I planted this selection in the spring, intending to use it as a ground cover until I found something else to plant. I never did. Until my drip irrigation had a problem, the mercardonia created a gorgeous mat from the profusion of bright-yellow flowers. Once the bed dried out, so did my mercardonia, so you can imagine my surprise this spring when the mercardonia came back from seed.

My drip irrigation is fixed, and I'm well on my way to having the bright-yellow carpet again.

Feed mercardonia once a week with a water-soluble 20-10-20 or 20-20-20 fertilizer, always following label instructions. This step keeps the growth and continuous flowering going all summer long.

So, don't give up on difficult strips of garden alongside the pavement or wherever your hot and dry trouble spot lies. Try some plants that perform well in demanding conditions.

Vermillionaire Blooms and Attracts until First Frost

Whenever I get the chance to speak to garden enthusiasts, I often give a wide-ranging presentation that includes some of my recommendations for sure-fire, must-have plants for your landscape and garden.

These often include Mississippi Medallion plants. One I'm really impressed with and think every landscape should have is Vermillionaire cuphea.

This plant is perennial in zones 8a and warmer, so this covers a large portion of Mississippi. For gardeners in north Mississippi, go ahead and use this plant as a great flowering annual. You won't be disappointed.

One reason I like Vermillionaire is that it does not require a lot of care. The only time I prune mine is when I cut it back to about six inches in the early spring to make room for the new season's growth.

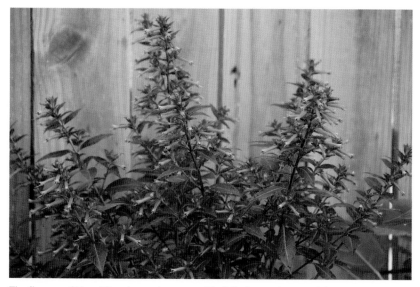

The flowers of Vermillionaire cuphea resemble little firecrackers, and they appear in abundant numbers up and down the stems and all over the entire plant. It blooms from May through frost.

Multiple swallowtail butterflies enjoy the nectar from the tubular flowers.

Vermillionaire make a great container plant.

The common name for Vermillionaire is firecracker or cigar plant, and I think the flowers do resemble little firecrackers. The plant produces abundant yellow, red, and orange tubular flowers up and down the stems and all over the entire plant. It literally is a mound of fiery-hot flowers and quite a sight all summer long.

Over the past several years, my Vermillionaire plants have been in flower from May through November or December, depending on frost. A late frost can take out initial growth and make the plant bloom a little late.

Vermillionaire cuphea is a magnet for pollinators, butterflies, and hummingbirds. I see an unusual insect known as the hummingbird moth visit this plant almost daily in the late afternoon or early evening in summer months. These day-flying moths resemble hummingbirds in flight and feed on flower nectar.

I also like seeing the different bumblebees drawn to this plant. In the fall, my Vermillionaire plants are literally buzzing when I walk by. Bumblebees feed in an interesting fashion. Since they're way too big to go in the flower opening, they just grab onto and chew through the flower petals to gain access to the delicious nectar.

By the end of summer, this plant will easily get three feet tall and wide when grown in-ground. In a big container, my plants get closer to four feet tall and wide. Container-grown plants get bigger because of the increased drainage in the container system.

Be sure to plant your Vermillionaire cuphea plants in full sun for the best flowering and tighter growth. Though the Vermillionaire tolerates droughty conditions, my plants enjoy my irrigation system that maintains consistent root zone moisture.

Feed monthly with a balanced fertilizer to keep the flower production going.

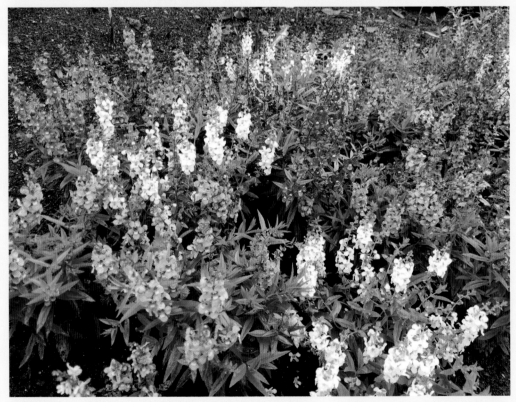

Serena Angelonias like this mix are winners in Mississippi gardens, despite the nonstop heat and humidity of summer.

Angelonia Varieties Handle Mississippi Heat and Humidity

Many seasoned gardeners, myself included, consider Angelonia one of the best plants for the hot summer garden.

Angelonia, a member of the snapdragon family, is actually called "summer snapdragon." It thrives in the full sun during the heat and humidity of summer. Since this describes our typical summer weather, tolerance to these conditions is a requirement for our Mississippi gardens and landscapes.

The garden world is dominated by plants with round flowers, so the spiky texture of the Angelonia flower stalks is a welcome addition to any summer garden.

In late April and early May, garden centers display some really good-looking plants for summer gardens. There are several Angelonia choices that will make outstanding contributions to your landscape.

In 2007, Serena Angelonia was selected as a Mississippi Medallion winner, and it has been a garden winner ever since. Flower colors include blues, pinks, violets, and white. Serena Angelonia grows to 12 inches tall and spreads up to 14 inches.

If you've grown and liked Serena Angelonia, then I know you will love the Serenita series, which are more dwarf and compact. Serenita's colors, in my opinion, are deeper and more vibrant than those of Serena. In fact, Serenita Pink was named an All-America Selection winner in 2014.

Like all Angelonia, Serenita plants are drought- and heat-tolerant, while continuing to produce a large number of flower stems all season long. Just to reinforce how good these plants are for our Mississippi gardens and landscapes, Serenita Angelonia was named a Mississippi Medallion winner for 2016.

Archangel Purple Angelonia features some of the largest individual Angelonia flowers. They are displayed on beautiful spikes that rise above the foliage from late spring to late summer.

Like its relative the snapdragon, Archangel Angelonia flower spikes are big enough for cutting and enjoying indoors. Archangel Purple Angelonia

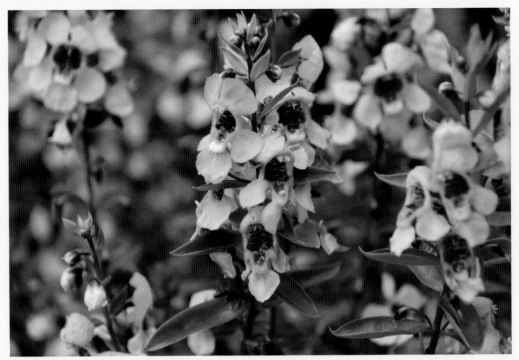

The Angelonia Serenita series has compact plants with vibrant colors, such as this Serenita Pink that was named an All-America Selection winner in 2014.

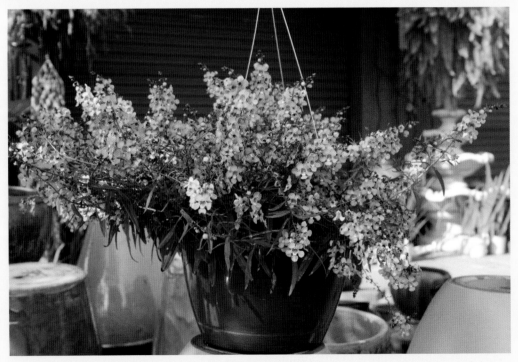

The Angel Mist variety of Angelonia, like this Blush selection, is free flowering, making it an exceptional choice for containers or hanging baskets.

grows to be about 14 inches tall, including the flowers, and it spreads to 12 inches.

Another variety of Angelonia that is worthy of a place in our Mississippi gardens is Angel Mist. This series is compact and low growing, with colors of white, pink, and purple. Best of all, these plants are free flowering, making them exceptional choices for containers or hanging baskets, as the stems sprawl and scramble over the container edge.

Once established, Angelonia is drought- and heat- tolerant, great attributes for Mississippi's hot summer conditions. Remember to apply supplemental irrigation during extended droughty periods. The effort will help ensure a healthy plant that continues to produce gorgeous flowers.

Angelonia thrives when planted in full sun in fertile, well-drained landscape beds. Add three to four inches of a good-quality mulch to improve even the most compacted clay soil. Angelonia will not be a good garden plant if the soil is poor or compacted with little air space.

Maintain a consistent supply of fertilizer for optimum performance and flowering. Fertilize with a complete, controlled-release garden fertilizer at planting. Supplement with water-soluble fertilizer monthly to keep Angelonia going strong.

Wherever you need summer color in your landscape, plant some Angelonia and watch it perform all summer long and beyond.

The bright purple leaves of Amethyst basil resemble the broad, flat leaves of common basil, and they have the same taste.

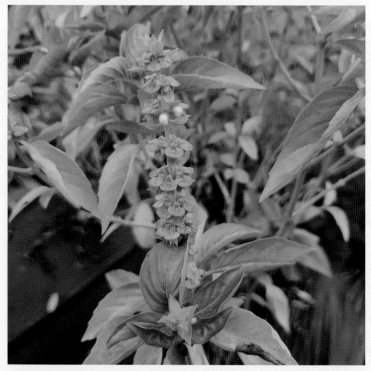

For the best foliage production, it's important to remove the flower heads from the basil through the growing season.

Summer Basil Is Beautiful and Tasty

For fresh summer recipes, nothing beats the taste of basil. Gardeners who want to grow basil for cooking can choose from a variety of colors, textures, and flavors, making this herb a garden showpiece.

Basil is one of the easiest herbs to grow during the hot summer months. Most gardeners start with common, or sweet, basil, which comes in a wide range of leaf sizes and textures. Lettuce leaf basil has leaves as big as a man's hand, and they are textured like lettuce. Try replacing traditional lettuce with a single leaf of it on a sandwich for a flavor sensation!

But basil plants are used for more than just food. They can also be landscape ornamentals. Purple-leaved varieties with pink flower heads are perfect for recipes and for adding to any mixed bouquet.

A basil that is attractive in both the vegetable and the flower garden is the Mississippi Medallion winner Purple Ruffles basil. The deep purple leaves are very fragrant, and the mature plant reaches 24 inches high and wide. Use this basil as a fresh garnish or harvest as baby greens to add color to salads.

Purple Ruffles is a winner in the landscape when companion-planted with another Mississippi Medallion plant, Port Gibson Pink verbena.

One of my favorite purple varieties is Amethyst. The bright purple leaves resemble the broad, flat leaves of common basil, and they have the same taste. This variety could be used to create a beautiful red pesto.

African blue basil is a member of another basil group that makes a good addition to the landscape. All parts of the plant have hairy surfaces. When properly cared for, African blue basil can grow up to four feet tall. The flowers are an attractive pink or purple.

Another member of this group is Holy basil, which has green and purple foliage. Flowers are pink and white, and the plant can grow to three feet tall. Both African blue and Holy basil can become perennial in the coastal counties. And don't worry about these getting too big; you can deadhead both to control growth.

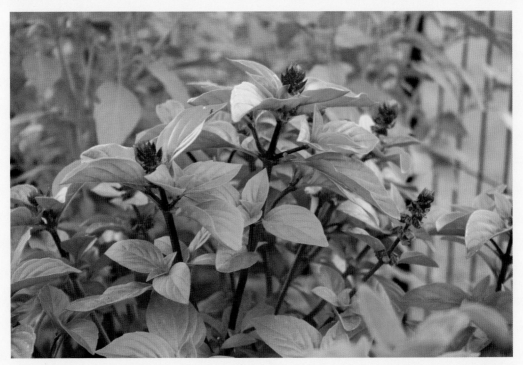

The Thai basil Queenette has gorgeous purple stems and flower heads that provide beautiful contrast to the bright green foliage.

You should deadhead faded basil flowers if you are growing it for cooking. This keeps plants producing tasty leaves rather than seeds.

If you are growing basil just for the landscape, pinching spent flower heads is not that critical. Many basil varieties have attractive flowers. For instance, the Thai basil varieties Siam Queen and Queenette have gorgeous purple stems and flower heads that provide beautiful contrast to the bright green foliage.

Basil thrives when grown in raised beds planted in well-drained soil, but the roots need consistent moisture. Water deeply each week and use a good-quality mulch to help conserve soil moisture and keep the soil cooler.

If you have limited space, grow basil in containers. Place containers on the porch or patio to keep them near your outdoor living area and handy for fresh summer recipes. Fertilize with a slow-release fertilizer at planting or use water-soluble formulations every three to four weeks.

After you make your first batch of fresh pesto from basil picked from your own garden, you will never go back the store-bought versions of pesto!

JUNE

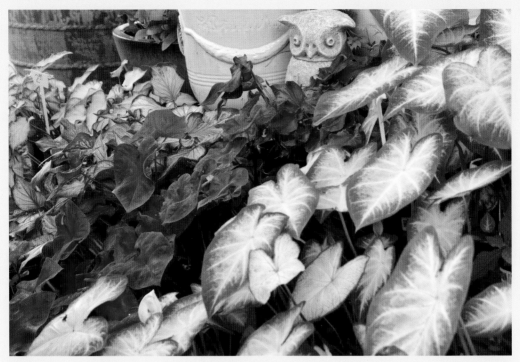

When kept consistently watered, caladiums are colorful additions to the landscape, even during the hottest part of the summer.

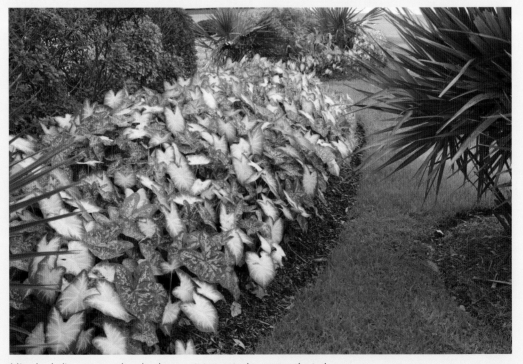

Mixed caladiums can make a landscape statement when mass planted.

Plant Caladiums for Seasonal Foliage Color

With all the annual flowering plants being displayed in garden centers in the early summer, you can be distracted and pass right by the gorgeous foliage colors of caladium. And this makes the caladiums feel bad.

Caladiums are among the most misunderstood plants in landscapes and gardens. Do you plant them in the sun, shade, or some kind of mixed sun and shade? The answer will be revealed later.

Though we may have questions about where to plant caladiums, many gardeners know they need this plant in their landscapes.

Who can argue against the plants' colorful leaves? The foliage is distinctive and really shows off against a background of green foundation or screening shrubs. Foliage colors range from solid reds, greens, and whites to very extravagant combinations that include spots, blotches, and stripes.

Most garden centers stock these plants, which instantly add color to the landscape. Hard-core gardeners who enjoy perusing the catalogs during the winter months might do things differently, but buying caladiums already growing is so much easier than planting the tubers in the spring and waiting for the plants to emerge.

Caladiums are colorful additions to the landscape, even during the hottest periods of summer. Consistent moisture is the key during these hot months. Plant in fertile, well-drained soil.

Mulch your caladium plants when they are transplanted to keep the soil moist and cool. Add three to four inches of good-quality mulch to improve even the most compacted clay soil.

If you're like me and consider caladiums as annual color, you just leave the tubers in the ground at the end of the season. But frugal gardeners can actually dig the tubers at the end of the year, store them and replant them the following year.

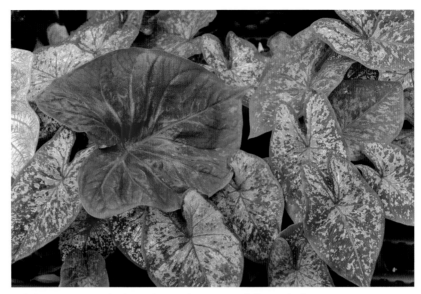

Caladiums are versatile plants that can be grown in full sun, shade, or part sun.

Dig them up at the end of the season before the leaves have lost all color. Since these are tropical plants, soil temperature is important, so dig them before temperatures drop below 55 degrees.

Unless you want a colorful mixture in the garden, sort the plants and label them by color. Allow tubers to dry in a protected area for about a week; your garage or covered patio works fine for this. After a week, remove the dried foliage and carefully brush any remaining garden soil off the tubers. Store in a container with dry peat moss in a cool, dry location until the following spring.

Now back to the question of where to plant caladiums in your landscape. The answer is actually pretty easy. Plant the caladiums wherever you want.

In my opinion, caladiums receiving at least partial shade tend to have better color development. But consider how and where caladiums are grown for the market. The vast majority of caladiums for our landscapes are field grown in Florida in the full sun. In fact, 95 percent of all caladiums are grown in the Sunshine State.

With literally thousands of selections available in the market, it's pretty much impossible to remember all the names. I think it doesn't matter what you choose. Just pick your favorite color(s) and get them planted in your garden!

Vitex Bloom Faithfully
Each Summer in the South

The first week of June is one of my favorite times in Mississippi landscapes and gardens. This is when the vitex begins to bloom with the regularity of Old Faithful.

The vitex flowering period begins around Memorial Day on the Gulf Coast and soon afterward in north Mississippi. The main flowering period lasts up to six weeks, but the show doesn't stop then. The plants continue to bloom sporadically for the rest of the summer.

There is a vitex planting right outside my office window, and, whenever I need to take a little break and stretch, I need only look at the gorgeous clusters of purplish-blue flowers to feel reinvigorated.

In 2002, vitex was named a Mississippi Medallion winner. Vitex is definitely a plant that makes gardeners and nongardeners alike stop and take notice.

Vitex is an outstanding small tree for Mississippi landscapes and looks great as a multitrunk specimen.

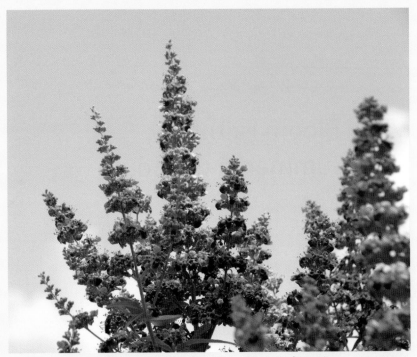

Vitex flower spikes can reach 18 inches long. During the initial flush, the show of flowers may resemble a hazy blue or purplish cloud.

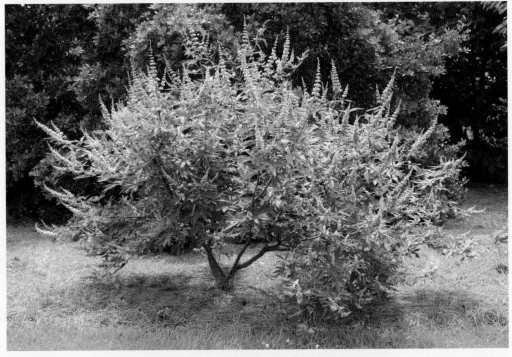

Shoal Creek vitex has bluer flowers and is a good small tree for the landscape.

The flowers, called spikes, are composed of many clusters of small, individual flowers. In some varieties, these spikes can be up to 18 inches long. Flower color varies from lavender to lilac and pale violet. The color can even be a brilliant, nearly fluorescent blue.

During the initial flush, the show of flowers may resemble a hazy blue or purplish cloud. On days when there is just the gentlest breeze, you can enjoy the flowers' delicate, slightly floral scent.

While the straight species Vitex is a great summer plant to choose, also look out for the improved Shoal Creek selection. The vigorous spring/summer flush of these flower spikes is large, and the blooms are a more intense and deeper blue than the regular species. The adventurous and persistent gardener can find pink and white varieties as well.

In 2011, Shoal Creek vitex was named a Louisiana Super Plant.

Vitex leaves are arranged opposite the blooms on distinctly square stems. Plants grow in clusters, with five to nine finger-like leaflets radiating from a single point. When crushed, the stems and foliage smell sweet. The foliage is a dark gray-green on top and bluish gray underneath. When mature, the leaves have slightly fuzzy undersides.

Vitex thrives in Mississippi's hot and humid weather extremely well, which makes this an outstanding small tree for our landscapes. It is also a good choice for the droughty periods we have each summer.

While vitex can be grown as a single-trunked tree, I think it is more attractive in the landscape when grown as a multitrunk specimen.

Vitex tolerates a wide range of pruning styles. It can be easily maintained as an 8- to 10-foot small tree. Pruning actually promotes more compact branching, resulting in a thicker, bushier plant. Since vitex flowers on new wood, which is the current season's growth, pruning actually encourages and enhances flowering.

One of my neighbors cut his small tree-form vitex back to the ground last fall. The plant started growing back this spring and is now a beautiful three-foot-tall bush. If allowed to grow naturally, it will reach up to twenty feet tall and wide.

Plant your vitex in partial shade to full sun for best flowering performance. While it tolerates a wide variety of soil conditions and textures, make sure the planting bed has well-drained soil.

Vitex makes a great companion when planted with the Mississippi-Medallion-winning, pink-flowering Sioux and white-flowering Natchez crape myrtles.

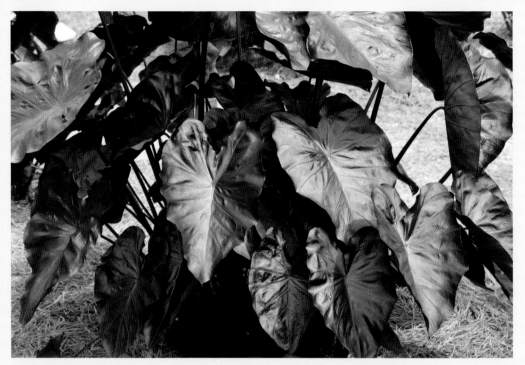

Colocasia selections with extremely dark leaves like Black Coral are dramatic landscape accents.

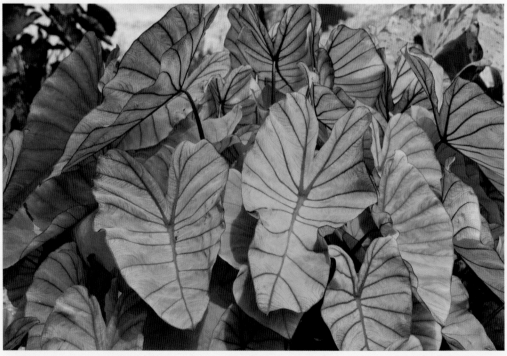

Colocasia Blue Hawaii is an elephant ear variety with large green leaves featuring prominent bluish-purple veins and wavy edges.

Elephant Ears Create a Tropical Paradise

Tropical plants, like elephant ears, just scream for attention and attract interest in any landscape. Most gardeners love elephant ears because they are easy-to-grow tropical plants that make a big impact.

There are three species commonly found in Mississippi landscapes: Alocasia, Colocasia, and Xanthosoma. Colocasia is my favorite elephant ear variety. Most Colocasia plants feature big leaves and big texture, but they're not all green. In fact, there are Colocasia varieties with black leaves.

Diamond Head is an outstanding Colocasia with foliage that is black and lustrous, just like its namesake volcanic cone on the island of Oahu. The huge foliage is at least 16 inches long and more than a foot wide.

For the darkest color development, grow Diamond Head in full sun. The leaves are a dark green if grown in the shade. Maintain consistent moisture, or the leaf edges will burn and turn a crinkly brown.

Black Coral has large, chocolate-black leaves with finely ruffled edges. The thick, black stems display the glossy arrow-shaped leaves, which are some of the darkest available on the market. The individual leaf surfaces have a corrugated appearance and prominent, deep-blue veins.

Black Coral is a great choice for a landscape focal point, reaching up to 4 feet tall. Like other Colocasia selections, these plants grow great in large containers with a consistent supply of moisture.

Blue Hawaii is another wonderful Colocasia variety. This plant has large green leaves featuring prominent bluish-purple veins. The edges are also bluish-purple and have a wavy undulation. The dark-burgundy petioles are glossy.

Blue Hawaii has a tight, clumping growth habit that is perfect for smaller areas in the landscape or containers on the patio.

If you appreciate a cool mojito after a hot day working in the landscape, you will find Colocasia Mojito to be a refreshing plant to have in your garden.

Colocasia Mojito leaves offer unique color patterns of lime green, chartreuse, purple, and almost black, each randomly splattered and splotched so that no two leaves are the same.

Each of its splendid leaves resembles an avant-garde artist's canvas. The unique color patterns of lime green, chartreuse, purple, and almost black are randomly splattered and splotched so that no two leaves are the same. I think the pattern colorations are intensified when the plant is grown in partial shade.

Colocasia overwinters most years without any cold protection all across Mississippi. In really cold weather, the central root structure may freeze and rot. Ironically, the small side shoots that are produced each year often survive even these coldest conditions.

To be on the safe side, especially in northern parts of the state, mulch your Colocasia each year. Always wait until after the first frost and use shredded leaves or other mulching materials to add a layer of protection.

Even if visiting the tropics isn't possible, we still can enjoy a tropical environment with Colocasia in our gardens.

Plan for SunPatiens and
New Guinea Impatiens

When summer officially begins, there are so many great plants we can grow during the season. But I really miss one that we can't grow in the summer: annual impatiens.

I always have impatiens in my late-winter and early-spring landscape. I've tried to oversummer some—in the same manner as we overwinter plants—in the shady areas of my garden, but I'm always met with bitter disappointment.

But all is not lost, because I can grow SunPatiens, one of my favorite summer-flowering plants.

SunPatiens, an improvement of shade-loving, New Guinea-type impatiens, love growing in the full sun during the hottest parts of summer. They bloom from the time they are planted in late April or May through fall.

SunPatiens love growing in full sun during the hottest parts of summer and bloom from the time they are planted in late April or May through fall.

New Guinea impatiens are strictly shade-loving plants that can complement their sun-loving cousins, the SunPatiens.

SunPatiens make an excellent summer season landscape border plant.

Because of their superior landscape performance, they were chosen as a Mississippi Medallion winner in 2011.

SunPatiens seem to flaunt their brilliant flower colors and heat tolerance. There are fifteen selections available in three different growth categories: vigorous growing, compact growing, and spreading.

Every year as I grow SunPatiens, I'm reminded of a much-loved plant I grew when living up north, the New Guinea impatiens. These strictly shade-loving plants can complement their sun-loving cousins, but they are hard to get in the extreme Southeast.

I have problems finding them for my Ocean Springs landscape, but, one spring, I found some at a big box store. They came as an unnamed series, but I didn't care: I had my New Guineas.

As you might imagine, New Guinea impatiens were originally found in New Guinea. Their foliage can range from dark green to bronzy reds and even variegated. I love the flowers, which seem much more flattened than SunPatiens and are available in a variety of colors from white to pink and magenta red. The individual flower petals have diamond-like sparkles.

New Guineas do not tolerate full sun for very long. A story I like to tell about New Guinea impatiens involves a golf course I worked at during my school days. Tuesday was always Ladies Day, and, to celebrate, we used New Guinea impatiens in 3-gallon containers as tee markers. For the rest of the week, we had to keep the plants in the deep shade of the course nursery to recover until the next Tuesday.

It's important to remember that SunPatiens and New Guinea impatiens require consistent moisture during the hot summer months. I use drip irrigation in my landscape beds to keep these plants happy during the heat.

Plant your SunPatiens and New Guinea impatiens late in the spring for your region of Mississippi. This timing allows the root system to become established, ensuring summer tolerance before the high temperatures roll in.

Now, I realize that, by late June, it's probably too late to easily find these plants for your landscape this summer, so make a note to pick up some of these great additions for your garden and landscape next spring. The beauty of these plants will make it worth the wait.

Sun coleus are low-maintenance, high-impact plants that perform beautifully in full-sun areas of Mississippi landscapes and gardens.

Electric Lime and Alabama coleus make an outstanding combination in the landscape.

Coleus Offers Summer Beauty without Much Work

With summer officially here and hot and humid weather firmly in place, many gardeners—myself included—like to look at a pretty landscape, but don't really want to get out and do much work in that same landscape.

So, plants that look good without much work pique my interest. One plant that doesn't disappoint me is Sun coleus.

This is a group of ornamental plants that have moved out of the shadows to take their rightful place in the full sun. They thrive in our Mississippi summers.

Sun coleus colors are rich and diverse, and the plants come in highly variegated variations They offer a kaleidoscope of combinations and are foolproof landscape plants. I love going to the garden centers and trying to decide which colorful selections to bring home.

Coleus have a growing season that lasts from planting in the spring to frost in the fall. I think they belong in every garden and landscape.

You need to take a close look at Electric Lime coleus, a Mississippi Medallion winner from 2010. At 24 inches tall, the beautiful lime-green foliage makes this an outstanding garden performer. Electric Lime coleus is a durable plant that can be paired with spring flowers, as well as mums in the fall.

One selection that has impressed many gardeners across the Deep South is Henna, a coleus with stunningly beautiful serrated foliage. The leaves are chartreuse and copper above, with a deep burgundy underneath.

But what about that shady corner or patio you have? Coleus also looks good in these settings, and that is where the shade-loving coleus takes its rightful place.

Many of these varieties have gone by the wayside as home gardeners prefer the sun-loving varieties, but one shade-loving coleus every gardener with a shady spot should consider is the Kong coleus series.

The Kong coleus has massive foliage and thrives in shady areas of the landscape.

Kong coleus was named a Mississippi Medallion award winner in 2006, and it is still a winner in the landscape today. Kong coleus have huge leaves large enough to cover a human face, living up to their namesake. Their foliage is the main focus, with bright colors featuring many shades of red and purple.

Coleus plants are easy to grow and are low-maintenance. They are almost foolproof when grown in well-drained landscape beds or containers and consistently watered through dry periods. They also are excellent in baskets as filler plants, especially in combination with a vining or cascading plant.

Since we grow coleus for its boldly colored foliage, there is no point in letting them use energy to develop flowers. Pinch these off to help develop a bushy plant. New varieties are bred to resist flowering until late in the season, if they bloom at all.

One key to success with coleus planted in landscape beds is to improve the soil with organic matter. In heavy clay soil, organic matter improves drainage and aeration, allowing better root development. In sandy areas, liberal amounts of organic matter help soil hold water and nutrients.

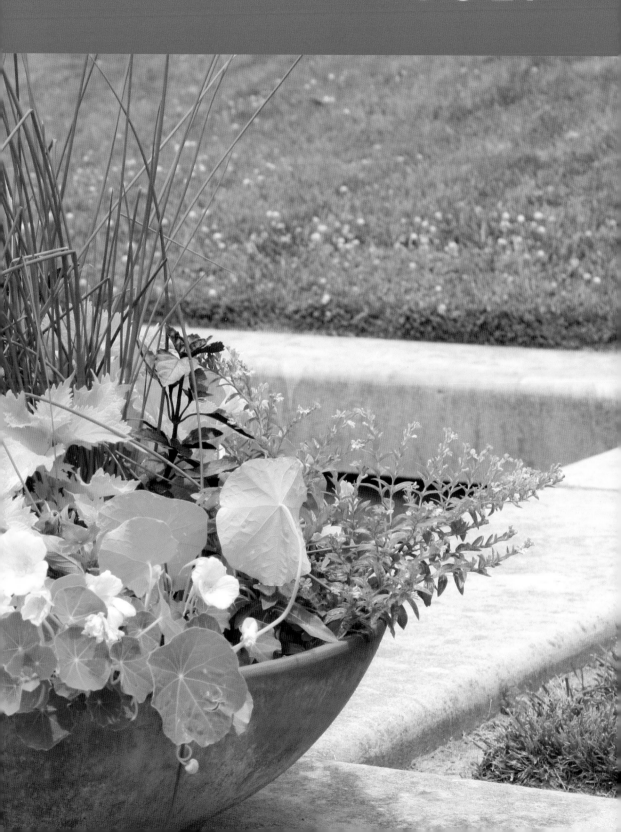

JULY

The vertical accent of Angelface Steel Blue angelonia with the pinks of Supertunia Vista Paradise are a great summer combination. A Bada Bing Scarlet begonia is in the background.

New Wonder scaevola and Blue My Mind evolvulus both have a spreading and trailing growth habit. Their branches intertwine and overspill the container with great numbers of flowers.

Combination Containers Offer Flowering Displays

I am a committed container-gardener for vegetables, but I also love containers for flowering plants. I firmly believe growing in containers is a fantastic way to enjoy a beautiful landscape and garden.

There are a couple of reasons for this, and one is that you don't have to weed—well, not as much. Also, container plants are ideal for small yards or for people who live in apartments and have only balconies for their plants.

I've found that you can grow more flowering plants and harvest more vegetables in a lot less space with containers than in-ground vegetable gardens.

In my coastal landscape, as well as many locations in Mississippi and around the country, the soil conditions are less than ideal. You can improve your soil, but this can be challenging for busy gardeners. Growing in containers is a great and easy alternative to the work involved in amending the soil.

Plants growing in containers can even be placed on benches or tables to raise the garden higher, making it possible for those with accessibility concerns to enjoy gardening.

So, what is the best type of container to use? There are beautiful containers in all shapes, sizes, and colors, and you can spend a lot of money on these. But I use simple black nursery containers as an inexpensive alternative. I grow my garden plants in 15- and 25-gallon containers.

In one container, I've combined two great summer plants: angelonia and Supertunia. Angelface Steel Blue angelonia makes a fantastic vertical accent. It has good branching with extra-large, silvery-lavender flowers. Supertunia Vista Paradise has gorgeous watermelon-pink flowers with salmon undertones. This plant fulfills its role as both a filler and a spiller.

In another large container, I've combined two plants that both have a spreading and a trailing growth habit and let them intertwine. New Wonder scaevola, also called fan flower, is heat-loving, and I've planted

This container overflowing with the low-growing purple foliage of Plum Dandy alternanthera looks great, but the vigorous plant crowded out the Golddust mecardonia originally planted as a companion.

it in blue, pink, and white. The flowers make scaevola look delicate, but the plants are really tough.

New Wonder's partner is Blue My Mind evolvulus. This plant has true blue flowers and is perfect for the western exposure in which I grow them. It produces flowers in great numbers, so it's a relief that deadheading isn't required.

Now, this last plant combination is a lesson in why you must choose compatible plants.

I thought a great combination would be the low-growing purple foliage of Plum Dandy Alternanthera and the golden-yellow flowers of Golddust mecardonia. These two played well together for about two weeks. After that, the Plum Dandy totally took over the container, which, by the way, still looks great.

For the best growth and flowering performance in containers, always use a commercially bagged potting mix. Potting mixes for containers need to be light and airy and drain well. Bagged mixes for container plants are often called potting or container mixes and have no soil at all.

These container mixes are found under a variety of trade names but are similar in their basic recipe. They are composed of organic components like peat moss, coir fiber, or bark. They are readily available at your local garden center and come in bag sizes from quarts all the way up to multicubic feet.

The selection of materials and bags can be confusing, so pay careful attention to the information printed on the bag.

Even in the middle of summer, there is still time to visit your favorite garden center and choose some plants for your own combination container.

JULY

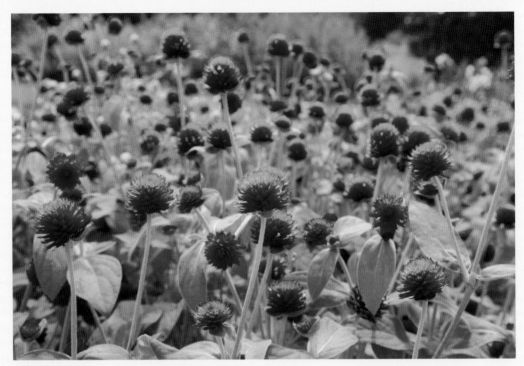

Gomphrenas, such as this All-Around Purple, are strong garden performers that thrive in the Mississippi heat and humidity.

Gomphrena Fireworks was chosen as a Mississippi Medallion winner in 2010. It is a big plant that makes a colorful impact in the landscape.

Heat-Loving Gomphrena Thrives in Mississippi

If you're looking for a tough plant that tolerates the combination of summer heat and humidity and keeps right on blooming, take a look at gomphrena.

Sometimes called globe amaranth, gomphrena is a plant that likes it hot—really hot! That means gomphrena grows great in Mississippi. Legend has it that the original planting was at the gates of Hades. Whether that is true or not, one thing is for certain: Gomphrena grows like heck.

Gomphrena produces flowers from early summer to frost in the fall. The flowers are cloverlike, everlasting, and straw-like in texture. The flower heads are actually bracts, which are leaves resembling petals. The small flowers are inconspicuous and only noticeable when the yellow stamens poke out. Flower colors range from white to purple and red.

Gomphrenas are native to Central America and related to the Alternanthera, which is another garden favorite of mine.

These plants have relatively few pest problems. Gomphrena's strong garden performance was recognized, as it was chosen as a Mississippi Medallion plant twice in the past eight years.

The first selection was All-Around Purple in 2008. These plants will reach up to 24 inches tall and wide.

The second Mississippi Medallion winner was Fireworks, chosen in 2010. True to its name, this selection is as beautiful as any fireworks display I've ever seen. The hot-pink flowers seem almost iridescent, and the little yellow tips seem to capture the essence of a celebratory explosion. Fireworks is a big plant, growing up to four feet tall and wide, so plan your landscape bed accordingly.

There are some other gomphrena selections I've enjoyed that I think you should consider.

If you like Fireworks but need a plant for a smaller space, then a new selection called Truffula is for you. This plant will grow about 24 inches by 24 inches and displays those gorgeous hot-pink flowers.

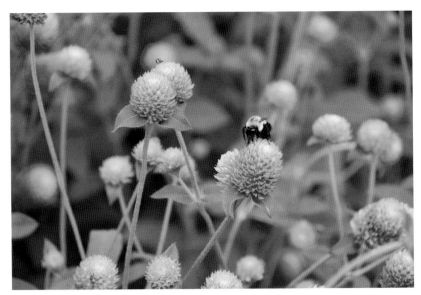

Ping Pong is a new gomphrena series that delivers a blast of color in any landscape bed.

The Gnome series includes compact plants that reach only 10 to 12 inches tall. They have white, pink, and purple flowers. This compact selection makes a fine container plant, or it can be used as a border along a sunny path.

A newer series is the Ping Pong gomphrena, which delivers a blast of color in any landscape bed. This is a medium-sized plant growing to about 16 inches tall.

Be sure to plant in the full sun. Gomphrena tolerates partial shade, but the best flowering show requires high light levels.

Your plants will thrive as long as the planting bed is well drained. Once established in the spring, gomphrena will actually become somewhat drought-tolerant, but you will have to water it during extended dry periods.

Gomphrena makes a good dried flower and is actually classified as an everlasting. To prepare the flowers, tie the stems in bunches and hang them upside down to dry in an airy room out of direct light. The flowers retain their color and are great additions to craft projects and dried flower arrangements.

You can also display the colorful, ball-shaped flowers in shallow dishes or use them in a potpourri mix.

Gomphrenas look great in a combination container paired with the Diamond Frost euphoria, another great Mississippi Medallion winner.

School Colors Make Good Gardening Combinations

Having a color scheme is a landscape design technique that gardeners have used for a long time.

A social media friend asked me once what people thought about planting their landscapes in the color scheme of their favorite athletic team. I think we've all seen the branding associated with ornamental plants in garden centers and nurseries. Can you imagine the branding possibilities with planting your favorite team's plants?

If you see gorgeous flowering plants in a team-branded container, will that influence your buying decisions? I think this is a decision best left to the titans of marketing and advertising. But I like the idea of letting your neighbors know who you'll be supporting this football season. And basketball season. And hockey season, for those who grew up in the North like I did.

Mahogany Splendor hibiscus looks a lot like a Japanese maple. Leaves are either a dramatic, dark purplish-burgundy or a rusty, intense green, depending on sun and shade.

Little Ruby is a nice, low-growing Alternanthera that has gorgeous, dark-burgundy foliage tinged with green.

Alternanthera Purple Knight is a landscape standard with its vibrant dark purple foliage.

Since I'm an Extension professor with Mississippi State University, let's take a look at a few plants with maroon foliage that will shine in your Mississippi landscape.

I already liked maroon- and burgundy-leaved plants before I became a Bulldog, and one of my absolute favorites is Mahogany Splendor hibiscus. This plant is perfect for our Mississippi gardens and landscapes.

If you take a quick look at the Mahogany Splendor hibiscus, you might think it is a Japanese maple. When grown in the full sun, the coarse and deeply serrated leaves become a dramatic, dark purplish-burgundy. When grown in a shady border, the leaves will be a rusty, intense green. This shrub grows to five feet tall or more and is tolerant of drought and deer browsing.

If Mahogany Splendor is too big for your garden, but you like the foliage and color, then you should like its smaller cousin, Little Zin. Little Zin is only about one-third the size of the larger plant, having a mature height of less than two feet. This is an excellent choice for a massed groundcover or as the filler in a large combination container.

Another plant that I think should be grown in more gardens is Alternanthera, also known as Joseph's Coat.

This plant really likes to show off its colorful foliage as the summer heats up. I like the fact that Joseph's Coat can be used in lieu of flowering annual bedding plants. A few of the taller selections can do double duty in the shrub border, or Joseph's Coat can provide great filler accent in a combination container.

Many varieties have a multitude of foliage colors from lime and chartreuse to bronzy reds and pinks, but right now I want to focus on burgundy-maroon leaves.

A nice, low-growing selection is Little Ruby, which has gorgeous dark-burgundy foliage tinged with green. The plant has an upright and mounding growth habit that is only 15 inches tall.

The landscape performance of Joseph's Coat was recognized in 2005 when Purple Knight Alternanthera was selected as a Mississippi Medallion winner. The foliage is a rich and vibrant dark purple through the summer until frost.

Purple Knight is a vigorous grower and can reach up to 36 inches tall. When pinched back, it grows more prostrate and spreading.

I realize not everyone is a Bulldog fan, so, for those gardeners cheering for other teams, go ahead and choose plants that fit your favorite sports color scheme.

The contrasting colors of Emerald Lace and Sweet Caroline purple sweet potatoes spice up the landscape. Ornamental sweet potatoes are excellent ground covers that feature beautiful, colorful foliage.

Sweet Caroline bronze and Sweet Caroline light green are sweet potatoes selected for their vivid and attractive leaves. The plants produce a flower that resembles a morning glory but is hidden by the foliage.

Ornamental Sweet Potatoes Add Plenty of Foliage Color

What relative of the morning glory makes an ornamental ground cover featuring beautiful, colorful foliage?

If your answer is ornamental sweet potatoes, then you are right. Ornamental sweet potatoes, known botanically as *Ipomoea batatas*, are actual sweet potatoes selected for their vivid and attractive leaves. The plants produce a flower that resembles a morning glory but is hidden by the foliage. They also produce edible tubers.

Longtime favorites include Margarita, with its large, lime-green leaves; Blackie, with its dark purple to black leaves; and Tricolor, with its green, pink, and white leaves. New varieties have an amazing array of colors and leaf shapes.

The Sweet Caroline series offers a wide selection for the landscape. The series has two leaf shapes: cut-leaf and heart-shaped. The colors available in cut-leaf include bronze, green, yellow, light green, purple, red, Emerald Lace, and Midnight Lace. Heart-shaped colors include light green, purple, red, and black.

A great way to spice up the landscape is to interplant contrasting colors of the ornamental sweet potato. Try combining Sweet Caroline bronze with light green, or Emerald Lace with Sweet Caroline purple.

Ornamental sweet potato is fantastic in combination container plantings. The vines cascade over the container edges and work their way around, between and sometimes over the other plants in the container. Coleus and cannas have a wide variety of foliage colors and make excellent planting partners for ornamental sweet potatoes.

Since ornamental sweet potatoes can be vigorous growers, they may become a little unruly and overrun less vigorous plants. Simply prune back to keep them in bounds. The pruning will not impact plant health and will help maintain dense growth.

Flea beetles are about the only serious pest ornamental sweet potatoes have. Check with the Mississippi State University Extension Service for the best control measures for these pests.

Bright Ideas Lime sweet potato makes a bright carpet in front of this planting of purple Angelonia.

Plant in full sun for the best color display.

The plants benefit from a good, well-drained organic soil. When preparing the planting bed, mix about two pounds of slow-release fertilizer per 100 square feet. This may be a bit wasteful, since ornamental sweet potatoes spread out quite a bit. Alternatively, drop a tablespoon of slow-release fertilizer into each planting hole to supply nutrients through the season.

Ornamental sweet potatoes need consistent moisture. Be sure to irrigate, especially in dry periods, to help maintain good plant health.

Ornamental sweet potatoes are annuals in Mississippi except in the coastal counties, where the vines will come back unless the winter was extremely cold.

Elsewhere, the vines may overwinter in protected microclimates. Or you can dig the tubers in the fall and store them in a cool, dry place. Plant tubers the following spring, along with other annual bedding plants.

Ornamental sweet potatoes add annual color to every landscape in which they are found. Why not enjoy them in yours?

AUGUST

The Pacifica Burgundy Halo's white eyes almost sparkle in the middle of these burgundy flowers. Its dark green, glossy foliage has a prominent rib in the middle.

These annual flowering vinca offer an exciting new color this year and are an All-America Selection for 2012. Jams 'N Jellies have velvety flowers that are a deep, dark purple. The nearly black flowers have a bright white eye.

Find Late-Summer Color with Flowering Vinca

By the time August arrives, everyone wants to find a durable, colorful plant, and one of my favorites is the annual flowering vinca.

Annual flowering vinca has dark-green, glossy foliage with a prominent rib in the middle. The foliage color makes a great background for the outstanding flower colors. These colors range from white to dark red, some with dark or white eyes.

Botanically speaking, annual flowering vinca is *Catharanthus rosea*, but some garden centers may label it Madagascar periwinkle.

An exciting color chosen as an All-America Selection for 2012 is Jams 'N Jellies, which has velvety flowers that are a deep, dark purple. The nearly black flowers have a bright-white eye.

Annual flowering vinca is a solid performer in our Mississippi gardens and landscapes. It was selected as a Mississippi Medallion winner in 2007 because of its garden and landscape performance, and I always make sure to plant them at my home.

The Titan series certainly lives up to its name. Titan has an upright growth habit and makes a statement: it can grow 16 inches tall and 12 inches wide. The three-inch flowers are the biggest of the annual flowering vinca, and 11 flower colors are available.

I'm really excited about the spreading growth habits of the newer varieties. I welcome the colorful groundcover mats in my landscape. Look for a few of my newer favorites, Soiree, Cora Cascade, and Mediterranean series, at the local garden center.

For the best landscape performance and flower color, always plant in the full sun. To help ensure landscape success, plant in raised beds to increase drainage around the root system. Annual flowering vinca does not like wet feet and will develop root rot.

These plants are heavy feeders, so be sure to incorporate a high-quality, slow-release fertilizer at planting time. Monthly feedings with a water-soluble 20-20-20 or 20-10-20 will keep those flowers blooming.

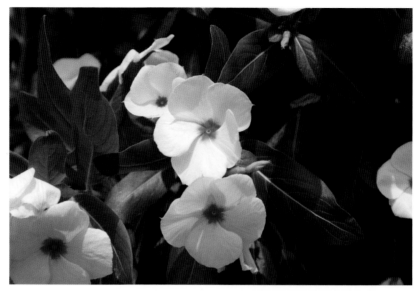

Annual flowering vinca, such as this Cora Apricot, is a solid performer in our Mississippi gardens and landscapes. Known botanically as Catharanthus rosea, some garden centers may label it Madagascar periwinkle.

Annual flowering vincas are drought-tolerant once established, but you should still maintain consistent soil moisture. Provide supplemental water during the dry periods we have every summer. These plants can tolerate hot and dry conditions, making them good choices for container plantings.

If you plant in hanging baskets, try the plants with spreading growth habits so they can spill out over the basket's edge.

If you grow them in containers, use a high-quality, peat-based potting media that is well drained and maintains adequate moisture. Feed weekly with water-soluble fertilizer when grown in containers.

Simple Concepts Make Accessible Gardening

Daily heat indexes routinely above the century mark make indoor air conditioning feel really fantastic and outdoor activities a challenge, but I've recently joined the ranks of gardeners who face a challenge unrelated to the weather.

I am sometimes a frustrated gardener who wants to get out into the heat and tinker in the garden. I've had a total knee replacement, and, at times, I need assistance with normal daily activities, let alone those in the landscape.

I know in the fairly near future I will catch up on landscape duties I have missed, but this experience reminded me that there are many others who love to garden but can't because of more serious or chronic conditions.

Place window boxes on a stepladder-type design for gardening that requires no bending.

Tabletop gardens are perfect for those who require the help of wheelchairs or scooters.

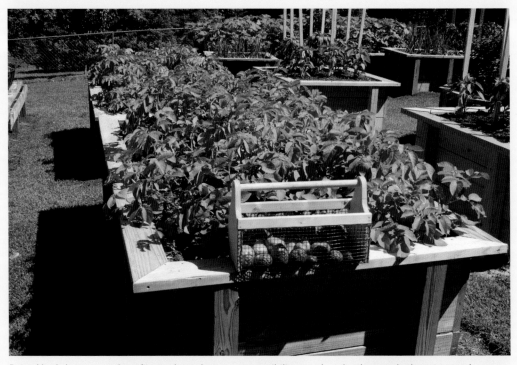

Raised beds bring many benefits to plants, but easy accessibility may be what has made them so popular.

The gardening and landscape industry is acutely aware of this segment of the population, and there is a lot of interest and effort focused on increasing accessibility to the landscape.

Each year, various polls indicate that gardening is a top homeowner choice for favorite and most popular hobby. Even in the hot summer, gardening is one of the few activities that can actually have a higher return on investment in terms of joy and satisfaction gained from the work and maintenance that goes into a garden and landscape.

A common problem I share with many other gardeners is a bad back. Gardening activities that require kneeling or bending over send many reaching for the heating pad and painkillers. Bad backs may help explain why raised garden beds are gaining in popularity. The benefits to the plants are many, but I suspect their increased use is really an accessibility issue.

Many garden and landscape shows and field days demonstrate different ideas for raised-bed gardening.

The Fall Flower and Garden Fest held each year at Mississippi State University's Truck Crops Branch Experiment Station in Crystal Springs always has an outstanding display of accessible gardening ideas. I saw one planter with a design similar to a stepladder. Window boxes are placed as the steps, allowing gardeners easier access for watering and harvest without bending.

Tabletop gardens are perfect for those who require the help of wheelchairs or scooters. It is a fairly easy thing to raise the growing bed to the needed height.

Another easy way to raise the garden to accessible heights is to grow your plants in plastic gutters attached to the fence. I use this "gutter garden" in my own yard to grow colorful pansies and violas in the cooler months.

Gutter gardens are really not a new idea. Commercial hydroponic vegetable growers have been using gutters for quite a while to help control the water needed in their operations. The beauty of this design is that the gutter can be placed at any height to accommodate the gardener.

Another popular vertical garden idea uses square bales of hay to grow vegetables. Transplants from lettuce to tomatoes are placed in the hay and grown above ground. Stack more than one square bale to achieve the height needed for accessibility from a standing or sitting position.

Making the garden more easily reached and maintained means that everyone—no matter their degree of mobility—can take advantage of the benefits a garden can provide.

Japanese fiber bananas planted around a large urn fountain and combined with Louisiana iris add a tropical flair to this outdoor patio.

Banana leaves can become weathered and tattered and enhance the tropical feel and look of your landscape.

Colorful Bananas Can Thrive across the State

A lot of gardeners are interested in creating a tropical feeling around their homes, and one of the easiest ways to do this is to add banana plants, either in the landscape or in large containers.

If you're about to quit reading because you think bananas can only be grown in coastal Mississippi and you live elsewhere, stick with me. I hope I can change your mind by describing some of the selections that are hardy for all landscapes in Mississippi.

A good all-around choice, especially for the beginning gardener, is the Japanese Fiber banana.

This is one of the easiest banana plants to grow, and it is cold hardy all across Mississippi. The coarse-textured foliage of the Japanese fiber banana is a bright green, and the plant can reach up to 10 feet tall. Even if it only gets to 5 feet tall, this plant has a presence in the landscape.

While the tropical green we commonly associate with bananas is relaxing, there are other colors in the banana palette.

One is Black Thai, a wonderful banana that has shown good cold hardiness. This banana has a really dark, deep purple stem and petiole, and the foliage is a dark green. It needs a large space in the landscape, as some specimens reach more than 15 feet tall.

One of the prettiest bananas is the selection Siam Ruby. The rich, burgundy color of the stem is stunning, and the irregular variegation of bright green on the burgundy foliage makes it seem to shimmer.

Siam Ruby usually reaches just four to five feet tall. This plant is suited to zones 8 and 9, where it will die back to the ground each winter.

Grow bananas in full sun in well-drained soil. Soil drainage is a critical factor, as many selections are not as hardy in soils that remain wet during the winter months. Bananas perform best in raised beds. The soil must be rich in organic matter, so amend your planting beds with three to four inches of good-quality compost and work it deeply into the soil.

The leaves of Bordelon banana are adorned with maroon splotches. The backs are solid red, and these are very visible as new leaves begin to unfurl.

When growing bananas in containers, never use the soil from your garden, no matter how good it is. Always use a high-quality commercial potting mix. These mixes are lightweight and have good drainage. For the container itself, choose one that holds at least 15 gallons to remain in proportion to the plant itself.

Bananas need consistent moisture, so be sure to irrigate yours on a regular basis, especially in dry weather. Keeping a heavy layer of mulch is critical in maintaining soil moisture for optimum growth.

Bananas are heavy feeders. Keep the soil nutrition at adequate levels in the landscape with a balanced, slow-release fertilizer such as a 14-14-14 lightly scratched in around each plant. For containers, I recommend you use a water-soluble fertilizer weekly in your regular watering schedule.

Bananas' coarse-textured foliage is right at home in almost any garden setting. Great places include around swimming pools or water features and paired with ginger, elephant ears, and Cajun hibiscus.

Hibiscus Family Offers Varieties for All Settings

One of the amazing things about plants is their diversity, and I don't mean simply the range of bloom colors and plant sizes available within a variety. I am intrigued by families of plants that vary so widely that you may not even know that they are related to each other!

A perfect example that grows in many of our home landscapes is the hibiscus.

Rose of Sharon is an outstanding landscape plant, and my landscape includes Orchid Satin, Pollypetite, and Purple Pillar. I have since added White Pillar to my collection.

Rose of Sharon is actually a popular member of the hibiscus family.

Another member of the hibiscus family is tropical hibiscus. These plants produce some of the most beautiful, complex, and mesmerizing

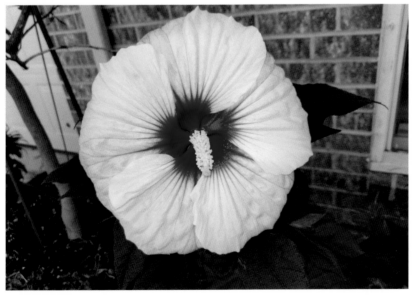

This hibiscus Summer Storm can produce large numbers of flowers up to nine inches in diameter above deep maroon-purple foliage.

The main attraction of Mahogany Splendor hibiscus is the foliage. The leaves are a dramatic purple burgundy with coarse, deep serrated edges.

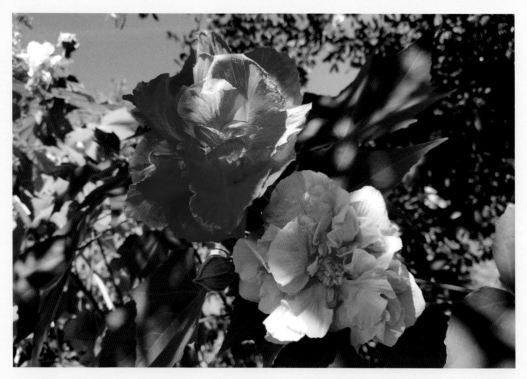

The Confederate Rose hibiscus produces literally hundreds of blooms that open nearly white, turn pink, and finally deteriorate as a bright red.

color combinations, ranging from bright yellow, pink, red, and white. Their flowers can be huge, with some exceeding nine inches in diameter.

Today, I want to tell you about some of my other favorite hibiscuses you can enjoy in your gardens and landscapes. And best of all, they're all winter-hardy, depending on zone.

Hardy hibiscus is very different from tropical hibiscus. As the name suggests, these plants can survive the winter. They add value to our late summer landscapes with their displays of enormous flowers. And when I say huge, I mean the flowers of hardy hibiscuses are *huge*—sometimes up to 12 inches across. In fact, they are often called "dinner plate" hibiscuses.

My favorite selection is Summerific Summer Storm.

I've measured some Summerific Summer Storm flowers at more than nine inches in diameter. And the number of flowers is huge, also. My Summer Storm has had more than 30 flower buds at once. The flowers are white with a red eye and are displayed above the maple-like, deep maroon-purple foliage.

Mahogany Splendor hibiscus is different from the other hibiscus varieties that have colorful flowers. Its flowers are inconspicuous, and the foliage is the main attraction.

It's easy to see why you might think this is a purple Japanese maple at first glance. Mahogany Splendor has dramatic purple-burgundy leaves with coarse, deeply serrated edges. When grown in the full sun, the color really develops into deep-burgundy tones.

Mahogany Splendor also grows well in partial shade, but the colors won't be as intense and will have green and rusty-brown tones instead.

Mahogany Splendor is perfect for our Mississippi gardens. The plants withstand extreme heat and drought. But, as you should with all drought-tolerant plants, be sure to water them periodically during times of extreme dryness.

One of my absolute favorite hibiscus shrubs has a common name that sounds nothing like a hibiscus. It is Confederate rose, commonly called cotton or cotton rosemallow.

These plants produce literally hundreds of blooms that open nearly white, turn pink, and finally deteriorate as a bright red.

So, if you are already a fan of one of these plants, consider shopping for a different type of hibiscus to enliven your home landscape.

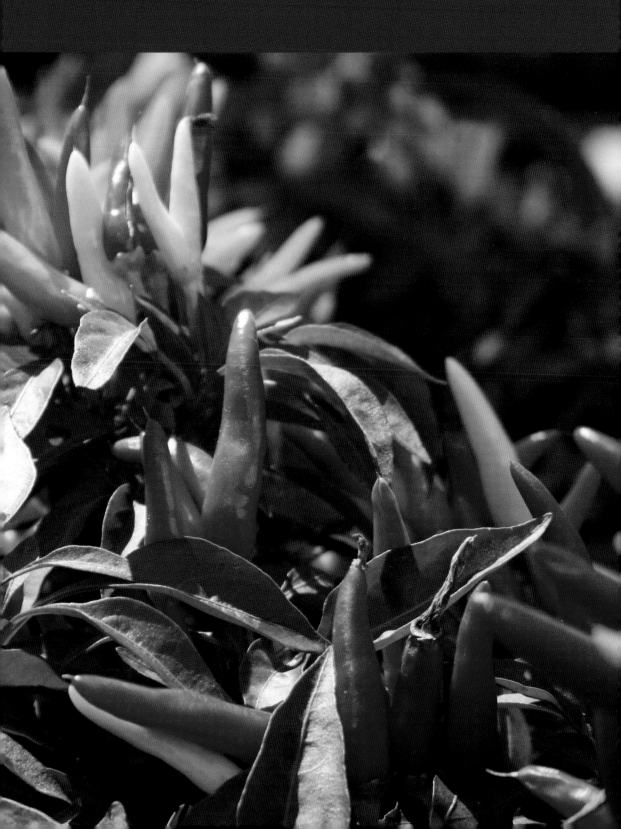

SEPTEMBER

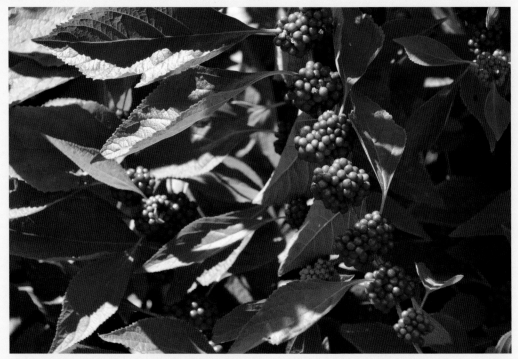

American beautyberry is a native plant species found all across Mississippi and much of the United States east of the Mississippi River.

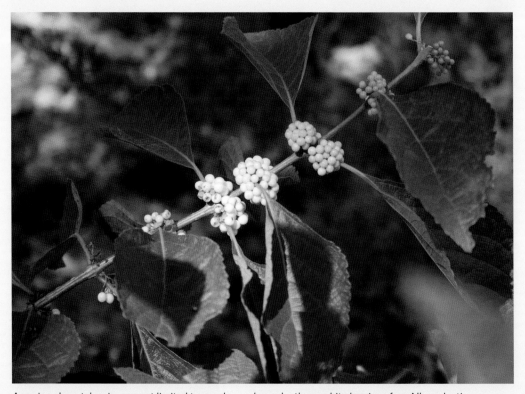

American beautyberries are not limited to purple, as shown by these white berries of an Alba selection.

Native Fall Beautyberry Belongs in the Landscape

I've noticed a common characteristic among us gardeners. As we go through the year, our favorite plants in the landscape and garden seem to change from week to week.

To other gardeners, this makes sense, as our landscape plants go through their life cycles. And, boy, am I glad that the plants are on different growth and development cycles. It would really be boring if they were all in sync.

One plant that always brings a smile to my face and lots of questions when I post it on social media is American beautyberry. This plant just seems to pop up randomly along roadsides, at the edges of wooded areas, and in people's yards.

American beautyberry, known botanically as *Callicarpa americana*, is a native plant species found all across Mississippi. It has a wide distribution range east of the Mississippi River in the mid-Atlantic and Gulf Coast regions.

Despite its native status, American beautyberry is quite at home and, in my opinion, desirable in the home landscape.

Its flowers are rather inconspicuous unless you're taking a really close look. I think the lavender-pink flowers are quite attractive. But what draws the most attention is the production of bright magenta-purple berries in tight clusters all up and down the arching stems of the straight species. Some plants have such heavy berry production that it seems like the leaves are growing out of the clusters.

You are not limited to just purple berries. The Alba selections have white berries, and I really like the Welch's Pink selection that was first found in west Texas. These have pastel-pink berries that bleach out into the fall.

If you like variegated plants, try the variegated beautyberry called Duet. The foliage is green with variable yellow margins, and it produces white berries.

Duet has a special place in the garden for me, because I discovered this selection. It is the only stable variegated beautyberry in the nursery trade. Check local nurseries for availability.

I discovered and propagated the variegated callicarpa selection Duet in 2000. This plant has green leaves with yellow margins and produces white berries in the fall.

It is worth noting that crape myrtle bark scale has been found on American beautyberries. It seems this destructive, nonnative insect pest to our beloved crape myrtles is using the native beautyberry to gain a foothold. It may also be using other species of Callicarpa grown in the Southeast as forage stock.

I've recently read where some folks are calling American beautyberry an invasive species, but that is far from the truth. It is true that it reseeds and birds move the seed around, but, since it is native to the Southeast, it shouldn't be considered invasive.

Beautyberry has a loose and open habit. One plant can be attractive, but a grouping of two or three creates a full cluster. The plants cross-pollinate, which helps ensure the fullest fruit production.

Beautyberry tolerates dry soil conditions and partial shade, but full sun provides for the healthiest plants and best fruit presentation. Be sure to maintain consistent soil moisture.

There are a few different species of beautyberry that have differences in mature size and berry arrangement. All are generally referred to as "beautyberry" in garden centers and nurseries. In my opinion, what the plants are called doesn't matter, so long as you have one or two in your landscape.

Regardless of the variety, beautyberry berries will persist into the fall and winter until the birds pick the branches clean.

Herbs Add Flavor and Color to the Garden and Plate

It may be early September, but now is a good time to start thinking about growing fresh herbs to harvest during the winter months.

Fresh herbs are relatively easy to grow in containers. In addition to offering a feast for the palate, herbs can offer a feast for the eyes. Many of the basic herb species are available in variegated or multicolored foliage. The multicolored ones work well in recipes, but they also make flavorful garnishes.

Common sage, *Salvia officinalis*, has a couple of attractive selections. Icertina has green leaves that are variegated with a steely grayish purple. A favorite of mine is the Tricolor selection, with its green leaves with white margins and interiors of pink and purple. Tricolor looks gorgeous in a container.

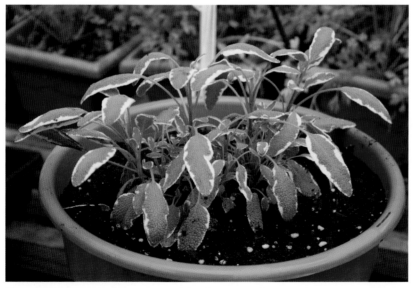

The green leaves with white margins of Tricolor, a type of sage, make it an attractive choice for a fall herb garden.

Amethyst basil is a must-have herb in my home garden. The colorful purple leaves are both ornamental and a vital ingredient for purple basil mojitos.

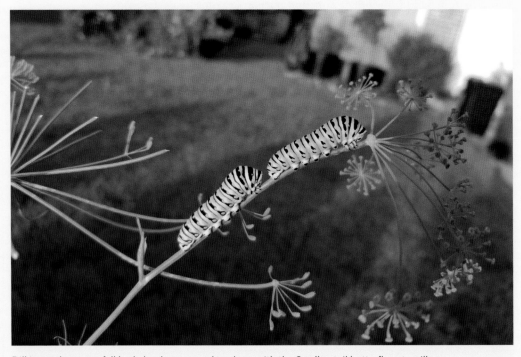

Dill is another great fall herb, but be prepared to share with the Swallowtail butterfly caterpillars.

Basil seems to be one of the most popular herbs with gardeners, but it also requires the most attention when temperatures start to dip. The Mississippi Medallion winner Purple Ruffles is an outstanding plant, with fragrant, deep-purple leaves and curly margins.

A newer purple basil I enjoy growing in the fall is the Amethyst selection. It has thick, turned-down leaves, like the classic Genovese basil. In fact, this is the first purple basil in its category. The almost-black leaves of this basil make it a real stunner.

A friend of mine used Amethyst to make purple basil mojitos, and the color extracted from the leaves was fantastic. Purple basil can also add a new twist to a classic pesto recipe.

Dill is a favorite in our household for dinner recipes but also as a forage plant for swallowtail butterfly caterpillars.

Many of these colorful herbs are available at your favorite garden center, and many more can be ordered from catalogs.

September is not too late to start a new herb garden from seed.

Use a high-quality, peat-based potting mix. Fertilize with a controlled-release fertilizer, using two to three tablespoons per plant blended into or top-dressed on the mix. Be sure to water well each day when first planted. As the temperatures cool down later this fall, you can water less frequently, but never let your herb containers dry out completely.

Growing fall herbs in containers is less overwhelming than a full garden and requires less weeding.

You may be surprised by how many herb containers will fit in a tight space. Even if you have only a small patio, balcony, or sunny kitchen window, you can still enjoy fresh herbs all fall and winter. The small containers are easy to transport indoors on cold nights.

To add more visual interest, use containers of different colors. Oranges, reds, and blues can add great color contrasts for container herbs.

Place your herb containers in an easily accessible spot so you can enjoy fresh herb goodness whenever your recipe calls for it!

Purple Flash is an ornamental pepper with purple and white variegated leaves. Fruit starts as dark marbles and matures to bright red.

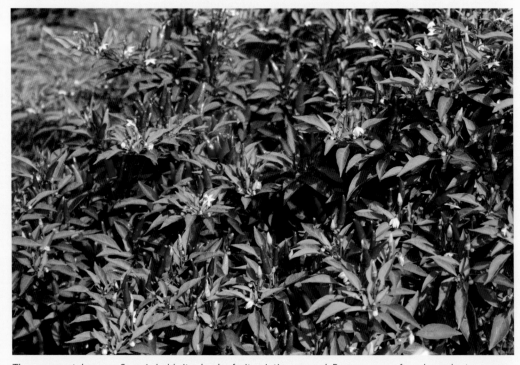

The ornamental pepper Sangria holds its slender fruit pointing upward. Peppers range from lavender to orange and red, and often all colors are on display at the same time.

Ornamental Peppers Make a Hot Splash in Landscapes

I often talk about my interest in using ornamental peppers in Mississippi landscapes. That's because I am a true "chili head."

I have a passion for hot peppers. Besides the culinary heat many of these hot peppers bring, they are colorful and have great potential for use in the landscape. There are many to choose from: some are big, others small; some come with green foliage, while others have purple; many offer multicolored fruit.

Using ornamental peppers can be a unique way to add interest to your garden.

One of the things gardeners like most about these ornamental peppers is their delightfully colored fruit, which is usually held upright, above the foliage.

Ornamental peppers can make outstanding houseplants. They grow very well in well-lit windows and, because they hold their fruit for extended periods, can make good holiday plants. In fact, some are being promoted for this very reason. Why have a poinsettia when you can celebrate with an ornamental poinsettia pepper?

One example of the versatility and value of ornamental peppers is Purple Flash, which was chosen as a Mississippi Medallion winner for 2010. With its purple and white variegated leaves, Purple Flash is one of the showiest peppers available on the market. The fruit start as dark marbles and mature to a bright red.

One of the ornamental aspects I like about peppers is the way they display their showy fruit in different ways.

The variety Sangria holds its slender fruit pointing upward boastfully. Pepper colors range from lavender to orange and red. Best of all, the plants always have a nice variety of the different colors at any given time.

Another interesting pepper is the Chenzo. This plant has elegant arching branches, and the fruit—ranging from green to black to red—hangs dramatically underneath.

The ornamental pepper Chenzo's elegant, arching branches hang the green to black to red fruit dramatically underneath.

Most ornamental peppers begin setting fruit as the temperatures heat up and will keep producing through the fall season. When the pepper plants are producing fruit, it is very common to have peppers in various stages of color.

This is a fantastic feature and provides for an ever-changing look in the landscape. It is common for fruit that has set to remain on the plant for a few months, maintaining its beautiful colors. Only when the fruit begins to dry will the color start to fade.

Ornamental peppers prefer to grow in consistently moist soil, but don't be overly generous with water, as the plants do not tolerate waterlogged soil. Fertilize with a good slow-release fertilizer early in the season. After fruit starts to set, there is no need for additional nutrition.

I must pass on a word of caution. Although most of these ornamental peppers are edible, they are extremely hot, so be careful to keep curious youngsters from trying the brightly colored fruit.

I realize I'm getting you interested in something that is too late to plant in September, although you may be able to find containerized plants if you look hard enough. If you really want to get started right away, seeds are available at many online seed houses and maybe at your local garden center or nursery.

If you can't get started using ornamental peppers this year, put them on your list for the spring and enjoy these hot plants in your landscape.

Express Yourself through Garden Art

Your garden is itself a form of personal expression, so what better way to say even more about yourself than with garden art?

When we think of a garden, we often think of flowering annuals and perennials, foundation shrubs like hollies and Indian hawthorns, and small ornamental trees. But add a sculpture or homemade piece of art, and you start to bridge the gap between the gardener and the garden.

Have a little fun with garden ornaments. Think about some you've seen while just driving around. Most people have seen a bed frame planted with flowering annuals. If you have seen one, I'm sure this "flower *bed*" brought a smile to your face.

Garden gnomes go way back as garden art, having been first used in German gardens of the mid-1800s. Made out of earthy terra cotta, they

This sculpture is surrounded by pink petunias, white variegated dianella and Big Blue Liriope.

Gnomes are always a welcome piece of garden art. This gnome lives in my home garden nestled in my ornamental sweet potato plantings.

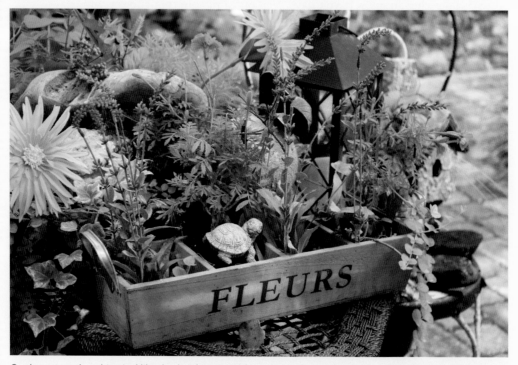

Garden art can be whimsical like this bottle crate with a variety of summer plants and a cute turtle figurine.

were painted and clothed like miners of the day, including the cute little pointed hats. From Germany, their use spread to France and England. In parts of Europe, a garden gnome is a status symbol.

Nowadays, garden gnomes are mass produced from plastic and found all around the globe.

Garden ornaments are an interesting contrast to their continually changing surroundings. While you're unlikely to swap out sculptures with the season, the look of the garden around the sculpture will change.

When I lived in Illinois, I had a ceramic mushroom patch. In the spring, beautiful Apricot Beauty tulips would emerge and bloom among the mushrooms, followed by flowering annuals, primarily marigolds. The flower colors changed with the season, but the mushrooms brought continuity to the landscape bed.

My parents in Tennessee have a sculpture of a golfer made out of steel round stock. In the summertime, it looks like someone playing through the hosta bed. Last winter, they sent me a picture taken right after a snowfall with the golfer silhouetted against the blanket of white.

Try tucking garden art into your landscape. My wife has an adorable green ceramic frog that looks like it is hiding in a mass of Silver Fog euphorbia. A friend in Hattiesburg has a small pond with massed elephant ear around the edges. Peeking out from underneath the canopy of foliage is a fisherman statue. I imagine fishing on a tropical island when I see this.

So, what kind of ornament should you put in your garden? The most important consideration is that you like it. If you like pink flamingos, there's nothing wrong with having a flock in the garden.

A second consideration should be durability. A wooden piece will deteriorate over time, so be sure it is sealed or painted. Concrete is a good choice, but the weight of these pieces can make rearranging difficult.

Once you've placed a piece of art in the garden, the garden suddenly becomes an even bigger part of who you are. And expressing ourselves is, of course, why we garden.

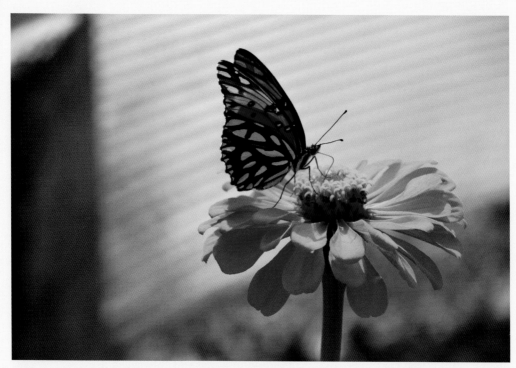

Zinnias are like candy for butterflies, and the big and colorful flowers always have butterflies visiting.

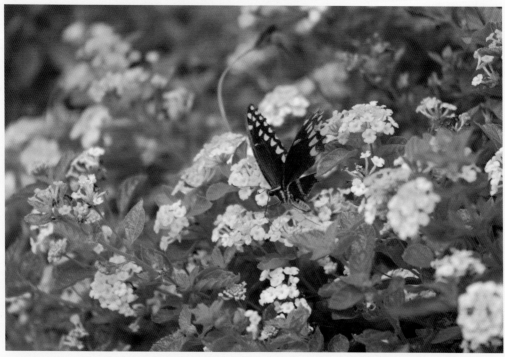

Butterflies love to hover and enjoy the nectar from the dense flower clusters of lantanas, such as this butter cream variety.

138

Gary's List of Top Butterfly Plants

The monarch butterfly may be the most recognized and loved insect in the United States, and fans of the insect consider it to be America's butterfly. Many people closely follow the annual spring and fall migration of monarch butterflies, which rivals the spring and fall migrations of hummingbirds.

Gardeners can select plants to attract monarchs and the wide variety of butterflies we have in Mississippi and the Southeast. Besides the monarch, the butterflies I see in my garden include swallowtails, painted ladies, Gulf fritillaries, and red admirals.

I realize we're eventually going to reach the end of summer, so use the list I'm about to give you as a planner for next year's garden. Be aware that these plants will attract a wide variety of pollinator insects in addition to butterflies, especially a wide variety of bumblebees.

Here are my top-performing, butterfly-attracting, must-have landscape and garden plants.

Butterfly weed is most known for being the primary forage plant of the monarch butterfly caterpillar. A wide variety of butterfly weed selections are available, but the ones most commonly found at garden centers are *Asclepias tuberosa* and *Asclepias curassavica*.

Coneflowers traditionally have large, purple petals with dark center cones. Newer selections have colors that range from purple to yellow, red, and white.

Coneflowers are pollinated primarily by butterflies. These plants have straw-like structures that only a butterfly's long proboscis can reach while they spread pollen from other flowers.

Salvia is a favorite in my garden because butterflies are attracted to the huge numbers of small, brightly colored flowers that bloom from summer all through fall. There are perennial and annual salvias. It doesn't matter which you use; just plant some of these plants.

Zinnia elegans—perhaps my favorite zinnia—are candy for butterflies. The big and colorful flowers always have butterfly visitors. I find the

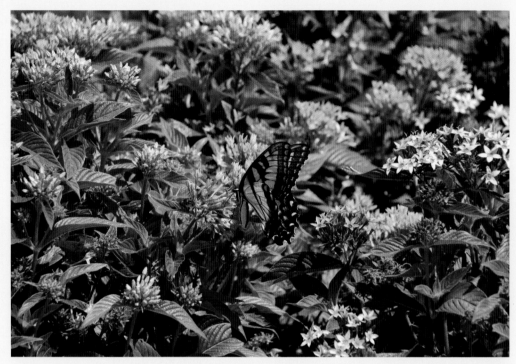

Pentas are an excellent summer color plant that is also a magnet for butterflies and hummingbirds because the flowers are a rich source of nectar.

single flowers get more action, as many of the double-flowered selections seem to have lost nectar production.

Lantana is an amazing plant with gorgeous clusters of small, warm yellow, red, and orange flowers. Butterflies love to hover and enjoy the nectar from these dense flower clusters.

Pentas are among our best summer color plants. They act like a magnet for butterflies and hummingbirds because the flowers are a rich source of nectar. Butterfly pentas were named a Mississippi Medallion winner in 2001.

Cuphea, particularly Vermillionaire, not only attracts butterflies, but it's also a bumblebee magnet. This plant can be literally alive with pollinator activity, especially in the fall. Vermillionaire is perennial in coastal counties and is well worth planting as an annual in north Mississippi.

Buddleias have a wide variety of colors and are a great selection for the garden. Their long panicles—some reaching 12 inches or more—display small, individual flowers that butterflies simply can't resist.

Of course, this list isn't an all-inclusive list of plants that attract butterflies. There are lots of other great plants to add to your butterfly garden, but these will get you started.

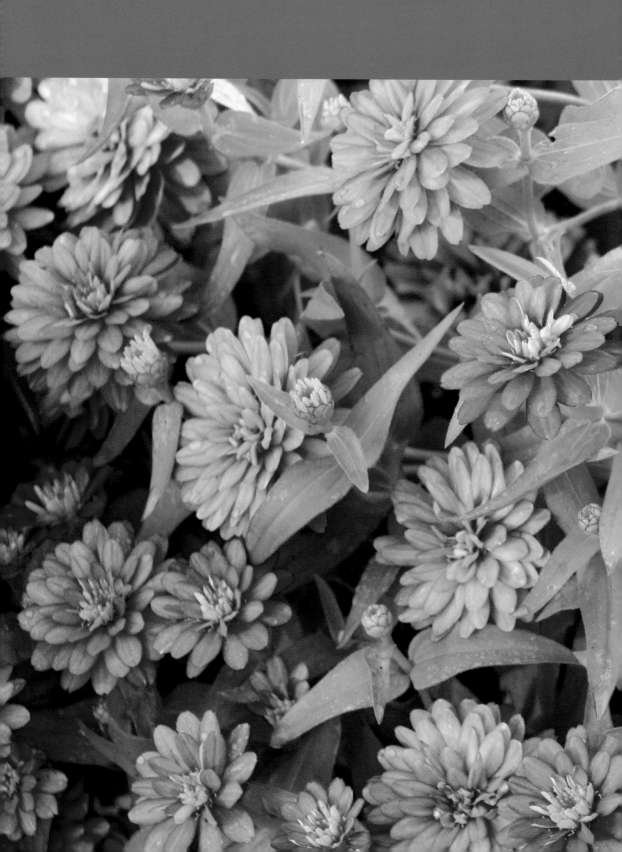

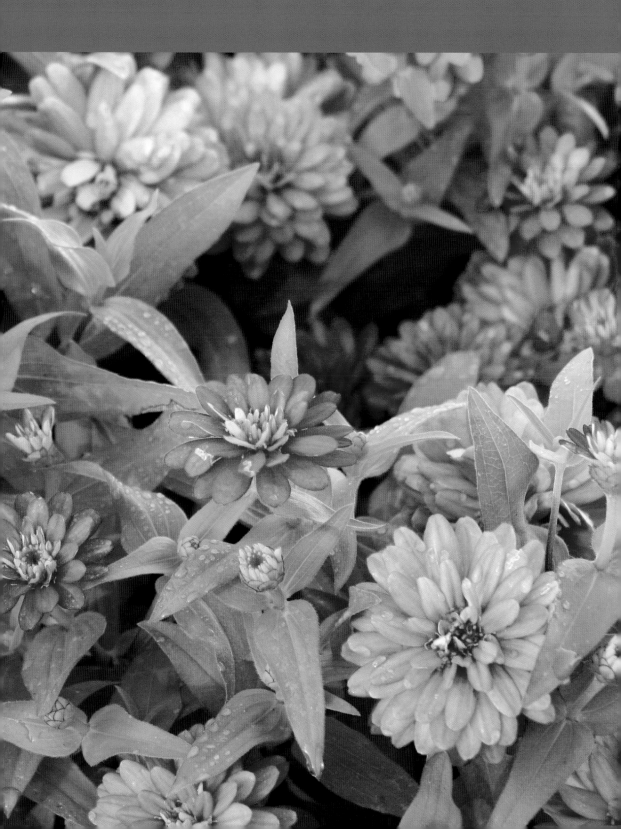

OCTOBER

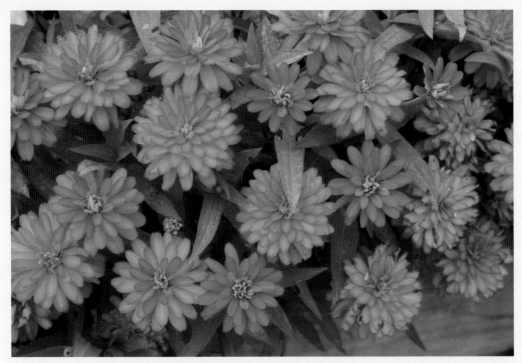

Zahara Double Fire zinnia produces mounds of scarlet-orange flowers all summer long.

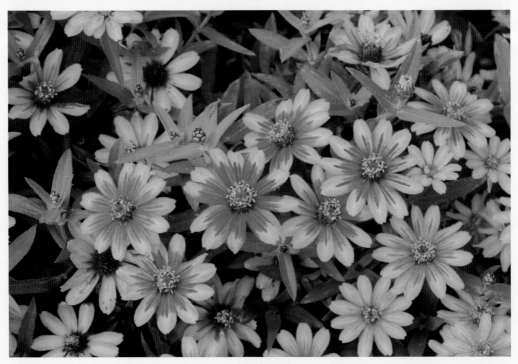

Sunburst is a great bicolor Zahara selection that has gold petals with red centers and holds its color all through the heat of the summer months.

Summer Zinnias Recharge in Fall's Cooler Weather

It's not just people who are happy when temperatures finally start to drop in the fall. Many summer-flowering annuals that look pretty worn out at Labor Day get a second wind and perk back up when it cools down.

For this reason, late September and October give us some of the best annual color of the entire year.

Some of my favorite fall-flowering summer annuals are Zahara zinnias, which produce mounds of colorful flowers. The plants are robust and have excellent branching to support the many flowers. Plus, these plants have a natural resistance to powdery mildew.

I really like the double-flowered selections Double Cherry and Double Fire. Double Cherry has deep-magenta blooms, while Double Fire is a hot scarlet-orange. Each has centers that lighten as the flowers mature.

I also like the bicolor selections. A favorite of mine is Starlight Rose, which has white petals with a splash of deep rose shining from the center. The deep-rose coloration is highly variable and does not develop very well when nights are warm. But when the fall cools off, the red stripe thickens and becomes more pronounced.

A newer introduction I really like is Sunburst. These flowers open gold, followed by the appearance of a red stripe down the center of the petals. Best yet is the fact that Sunburst flower colors are very consistent throughout the flowering season.

Zahara zinnias are well suited for container gardening. You can extend the flowering season by bringing the containers inside when cold weather arrives.

As gorgeous as Zahara zinnias are in the fall, they just may take a backseat to cactus-flowered zinnias. These zinnias may seem like a new type for the landscape, but they are actually heirloom zinnias that have been around since the 1920s.

Their flowers have a completely different texture from what you may be familiar with. Each full, double flower displays masses of thin, almost needle-like petals.

Cactus-flower zinnias such as this Inca are very different from traditional zinnias. Each flower displays masses of thin, almost needle-like petals that come in a range of long-lasting colors.

Cactus-flowered zinnias come in a range of long-lasting flower colors, but it's hard to ignore the variety called Inca. This selection has spectacularly vivid blazing-orange flowers. Typically, these plants grow to 30 inches tall with sturdy stems. The stems need to be sturdy, because each flower can be 5 inches in diameter.

When growing yours at home, keep a two- to three-inch layer of mulch to maintain soil moisture. Although zinnias are tolerant of drought conditions, they still need supplemental irrigation during periods of extreme drought. Irrigation needs drop dramatically with the onset of lower temperatures.

If you do irrigate your fall zinnias, I find soaker hoses or other drip-type systems are superior and efficient methods of maintaining soil moisture.

And even though it is the fall, don't neglect the feeding needs of your zinnias. I recommend you use a water-soluble fertilizer as an easy way to keep the plants fed in the fall.

So, go ahead and enjoy the fall resurgence of zinnias in your landscape. There will be plenty of time to plant traditional cool-season flowering annuals later this fall.

Heirloom Confederate Rose Thrives across the State

You may realize I have weekly favorite plants, and one of my favorites starts blooming in earnest in late September and early October. I think the sheer number of flowers on the Confederate rose makes this plant a must-have in our Mississippi landscapes.

Confederate rose is sometimes called Cotton rose or Cotton rosemallow. Despite the references to cotton, this plant is actually a hibiscus that originated in Asia.

Each plant produces literally hundreds of blooms, which open nearly white, turn pink, and finally turn a bright red as they deteriorate with age. As the older flowers start to fade, new ones are opening. On a typical day, these plants have loads of flowers in varying shades of white, pink, and dark pink.

Confederate rose is an heirloom plant that blooms prolifically in late summer and fall.

The blooms of the Confederate rose are large and change color from white to pink and bright red as they age.

Confederate rose plants can grow 10 to 20 feet tall, so keep their mature height in mind when making planting decisions.

Confederate rose is a wonderful plant that is really unknown outside the Southeast, where it has been grown in the landscape for hundreds of years.

Confederate rose is in its prime blooming season in the late summer and fall. I love the six-inch-diameter flowers it produces at this time. When we have a mild winter in Biloxi at the Mississippi State University Coastal Research and Extension Center, we sometimes have specimens in their full glory in March.

When choosing a place for this plant in your landscape, first consider that it needs a full-sun location. Then consider its future size, because it can reach an impressive height of 10 to 20 feet or more. I think the best landscape use is as a specimen plant in order to properly display the prodigious number of gorgeous flowers.

Confederate rose likes a consistently moist planting bed, but it does not like wet feet. The leaves are large and frequently start to look a little wilted on Mississippi's hot summer days. But not to worry. This plant will bounce back by the next morning, as long as the home gardener maintains consistent soil moisture.

Typically, this plant dies back to the ground after a hard frost, except in the extreme coastal counties where it can overwinter. Confederate rose will emerge from winter dormancy to shoot up 8 to 10 feet or more the next season. Cut Confederate rose back to 4 to 6 inches in late winter to accommodate the next season's growth, which springs up from the roots.

Confederate rose is a perfect example of an heirloom ornamental plant that everyone can enjoy in their gardens and landscapes. Take that, heirloom vegetables!

Heirloom ornamental plants are also called pass-along plants. Fall is the best time to collect root cuttings, but it can be difficult to propagate cuttings following the old-time methods.

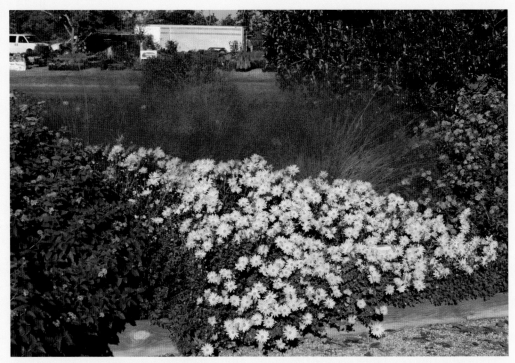

Gulf muhly grass combines beautifully in the landscape with the heirloom chrysanthemum Clara Curtis.

Gulf muhly grass makes a big splash in the fall, when it flowers in billowy masses that resemble pink clouds in the landscape. Backlit by the rising sun, the grass seems to glow.

Pink Gulf Muhly Grass Offers a Fall Color Treat

Gardeners don't always think of native grasses as a landscape high-light, but fall is the time when one really puts on a show. Gulf muhly grass is at its best in the fall and winter months.

Gulf muhly grass has a unique texture with spiky, upright leaves that offer summer interest. But it's the plant's last, grand flourish that creates true landscape excitement.

Muhly grass flowers in billowy masses that resemble pink clouds in the landscape. As long as there isn't a hard freeze, the color will hold. Even after a freeze, the flower heads keep their airy shape.

A planting at the Coastal Research and Extension Center in Biloxi is truly gorgeous on any sunny fall morning. The rising sun backlights the Gulf muhly grass, making it seem to glow in the rich morning light. Anyone seeing a display like this can recognize the significant impact landscape grasses have in the winter.

The Truck Crops Branch Experiment Station in Crystal Springs has a long-standing combination of Gulf muhly grass and the heirloom chrysanthemum Clara Curtis that is worth seeing.

Gulf muhly grass has had an important role in the history of the Southeast, primarily in the Charleston, South Carolina, area. For hundreds of years, people have harvested the long, wiry grass blades and used them, along with other native plant materials, to weave sweetgrass baskets. This basket-making practice continues to this day.

November is a great time to plant this native grass, which was chosen as a Mississippi Medallion native plant winner in 2010.

Select a landscape site that receives at least six hours of full sun. Turn over the soil, working in at least three to four inches of quality compost. Always set the plants a little bit higher than the native grade of the landscape bed. This practice aids drainage and is always a good idea in Mississippi landscapes and gardens.

White Cloud is a beautiful muhly grass selection.

Consider spacing needs carefully. While a mass planting of Gulf muhly grass is gorgeous, these plants need their individual space. Plants can grow up to four feet wide, so place them three feet apart in the landscape. This spacing will achieve that filled-in, mass look.

Like all ornamental grasses, there is really only one maintenance step that you must not neglect. In late winter, cut the grass clumps back to six inches tall before spring growth starts. This trimming clears the way for the new foliage and results in a nicely formed clump.

Don't be tempted to cut them back any earlier than this. If you do, you remove the dried flower stems that create movement with the wind and habitat for wildlife.

Other species are all called muhly grass and have similar landscape performance, but most of these have white flower heads. A lot of garden centers will lump these all together and call them muhly grass. It really does not matter what it is called, but muhly grass should be in your landscape.

Just remember it's the Gulf muhly grass, *Muhlenbergia capilaris*, that has the pink flower heads.

Lycoris Bring Unexpected Beauty to Fall Landscapes

I love the autumn season because we're starting to recover from Mississippi's hot and humid summer with cooler weather. Not only do gardeners appreciate the season change, but so do many of our landscape plants.

Fall heralds the appearance of one of the most fascinating flowering plants we can enjoy in our landscapes and gardens. Of course, I'm referring to Lycoris. You recognize them as those flowers that seem to pop up out of nowhere.

Now, I realize that most gardeners don't call this plant by its botanical name.

Most of the common names for Lycoris rely on the fact that this plant has a unique way of growing. In the early spring, strap-like foliage appears and looks very much like daffodil foliage, but without any flowering. It disappears after a few weeks.

Evidence that the Lycoris requires very little care is the fact that the flowers pop up completely unattended in landscapes.

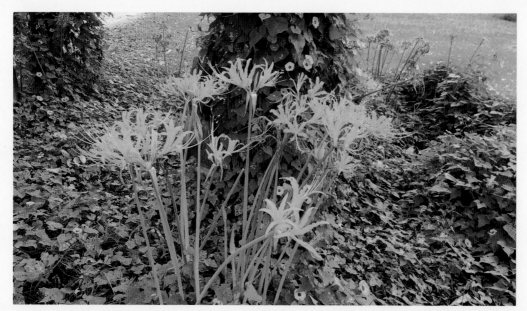

The yellow selection of Lycoris is not widely distributed and certainly a pretty companion for the red variety.

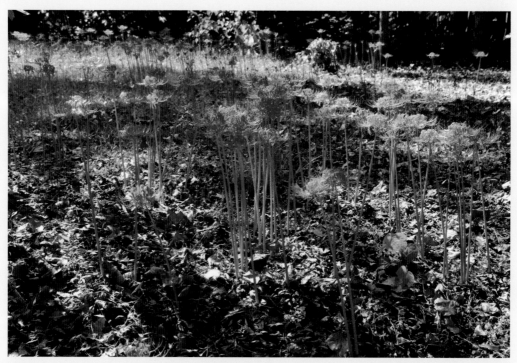

The Lycoris blooms without any leaves when the tall flower stalks seem to appear magically across landscapes and outdoor areas and results in common names including spider lilies, surprise lilies, and nekkid ladies.

Then, in the fall, tall flower stalks seem to magically appear and surprise many folks. This gives rise to some of the popular common names for Lycoris: "surprise" or "resurrection" lilies.

Another name more commonly used in the coastal region is "hurricane lily." This name comes from the fact that they bloom during hurricane season, not because they are storm predictors.

But that brings me to this plant's most fun name. Botanically, when a plant blooms without any leaves, the flowers are referred to as being naked. So, you may have called Lycoris "naked ladies," or, as some horticultural aficionados say, "nekkid ladies."

Lycoris flowers are very fine-textured and delicate. Their exotic and spidery look leads to yet another common name: "spider lilies." They remind me of the spidery flowers of our spring-blooming native azaleas.

In Mississippi, we primarily see the red *Lycoris radiata*, which is a long-lived heirloom and a popular pass-along plant with gardeners. There are also beautiful yellow selections and even a white variety.

There are many other Lycoris species, but most need a colder winter than we typically have in Mississippi.

Plant Lycoris bulbs in the fall. Some independent garden centers will have the bulbs for sale, but, if you have friends with Lycoris growing in their landscapes, ask if you can dig up a few to take home. Most gardeners are willing to share this wonderful plant.

Plant in the full sun. Since Lycoris has such a unique growth habit, be careful to choose a site where the emerging flowers won't get trampled or cut with the lawn mower.

Whatever you call Lycoris, this is one plant everyone should have at least a couple of in their landscape. They're easy to care for. Proof of this is the fact that they are commonly seen growing completely unattended at old home sites, long after the house is gone.

NOVEMBER

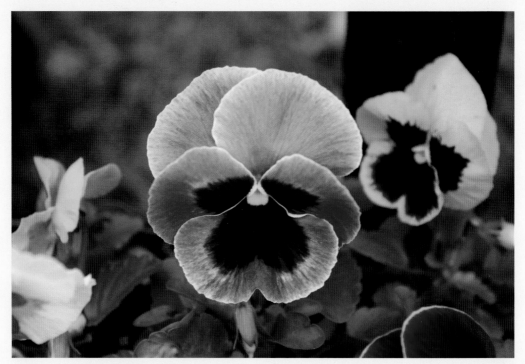

Matrix pansies flower early and provide tough, annual, cool-season color for Mississippi gardens. These Matrix pansies display the traditional dark blotch.

Pansies are called clear if the blooms display pure colors without a dark blotch. These Matrix pansies create an impressive, colorful landscape carpet.

Matrix and Cool Wave Pansies Highlight Winter Gardens

Anytime temperatures dip below 60 degrees, I pull out my hoodie sweatshirts and long pants in anticipation of cold weather. But the falling temperatures also signal something truly great: racks and racks of great cool-season color as pansies fill local garden centers.

People always ask me about the right time to plant pansies. The answer is, right now. November is an absolutely great time to plant, and the ones I love to plant are Matrix pansies.

Matrix pansies flower early. Strong stems hold the huge blooms above the foliage, allowing the petals to flutter in the slightest breeze.

For the past several years, I have thought that the Matrix group is the best for gardeners in Mississippi. They offer some of the toughest annual cool-season color plants and should be planted in everyone's garden and landscape.

Matrix pansies come in a huge range of colors and styles. The traditional ones have dark blotches, while the clear varieties are pure colors without the blotches. Matrix pansies are also available in color-coordinated mixes instead of the traditional, random color mixes.

Matrixes have a freely branching growth habit and reach about eight inches tall and wide. When massed in a bed, as pansies were meant to be planted, they create an impressive, colorful landscape carpet.

While it's obvious I'm a rabid Matrix fan, I have a growing fondness for what may be an even better variety for us to grow: Cool Wave pansies.

Cool Wave has a unique, trailing growth habit that makes it a must-have in your garden. These pansies are much more vigorous than standard varieties. The plants are well branched and will fill a landscape bed or hanging basket with good color from fall all the way to next spring.

Flower colors are very attractive, and there is quite a selection available. Along with white, yellow, and purple, there is Violet Wing, Frost, Blueberry Swirl, and my favorite, Sunshine N' Wine, which is a bright, sunny yellow with mellow burgundy wing and accented flowers. All

Cool Wave pansies have a unique, trailing growth habit that makes them perfect for landscapes or baskets.

the flowers have whisker lines radiating from the center, resembling an artist's delicate brushstrokes.

Cold tolerance is one attribute that impresses me about pansies in the garden and landscape, and Cool Wave pansies are no exception.

As with all annual color, always work a little compost into the soil before planting. Be sure to maintain a consistent soil moisture, and feed them with a water-soluble fertilizer, even during the winter. Pansies need at least six hours of full sun each day for the best flowering and growth.

Pansies may be the perfect winter-flowering annual, as the plants can freeze solid and thaw with little damage. In response to the cold, their leaves will be tinged purple and their flowers nipped back. But once it gets a little warmer, the flowering will rev up again.

Don't wait. Get to the garden center this weekend and choose some of these colorful cool-season plants for your landscape!

Violas Thrive in Winter Landscapes and Containers

When you consider that violas tolerate winter weather and can thrive in both the landscape and containers, it is no wonder that they are a favorite bedding plant for Mississippi gardeners.

The viola, which is related to the pansy, will bloom from Thanksgiving to Easter and beyond. In fact, violas are often hardier than pansies.

Violas are known botanically as *Viola cornuta* but are commonly called Johnny Jump Ups. They are prolific seed producers, and it is quite common for viola to act as a perennial in the home garden.

Garden centers carry quite a selection of violas in the late fall. The colors seem to be endless in variety.

One of the newer offerings is the Penny viola family. The Penny Citrus mix is a prolific flower producer. The flowers are larger than the normal viola and produced in prolific numbers. The flowers are displayed high above the compact, lush, green foliage in a way that begs for attention.

Violas are winter-hardy flowers that perform beautifully in landscapes and containers. Viola Penny Azure is a gorgeous white and bright blue flower with purple streaks.

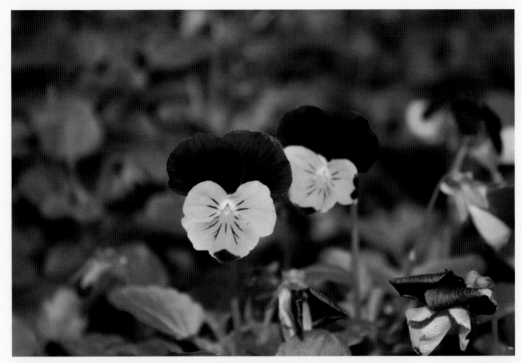

Violas come in gorgeous colors and last from Thanksgiving through Easter. The Sorbet series has a seemingly limitless selection of colors, such as Sorbet Orange Duet, a beautiful orange and purple bicolor.

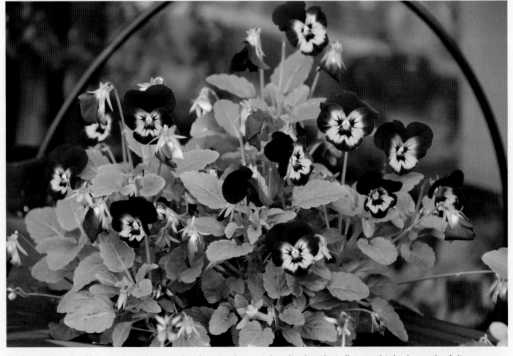

Sorbet Midnight Glow is a great example, showing how violas display their flowers high above the foliage.

Penny Citrus plants are four to six inches tall and wide. Flower colors include cream, orange, primrose, yellow, and yellow frost.

I really like the Penny Azure, which is a gorgeous white and bright blue flower with purple streaks. The color of the flower starts off as light blue and then transitions to bright blue.

The Sorbet series is another good choice that performs well in the landscape or container. With its seemingly limitless selections of colors, you can't go wrong with Sorbet viola.

Violas grow best in consistently moist, well-drained soil. Amend the soil with good, composted organic matter before planting. Violas prefer growing in full sun.

For best performance now and in the spring, plant violas before the cold weather sets in. This allows the root system to become established. Apply a layer of mulch to help with overwintering. This extra layer of protection is especially important in north Mississippi.

Keep the soil nutrition at optimum levels to ensure that the violas keep blooming throughout the growing season. Add a pound of good slow-release fertilizer for each 100 square feet of garden bed. Have your soil tested and amend it as recommended. Violas provide the best flower show with soil pH at 5.8 and below.

There is nothing lonelier than a viola planted all by itself in a big flower bed. For the best landscape performance and display, always plant viola in big masses. Remember that most violas only spread up to six inches, so it is important to space them properly. Plant violas in the landscape six inches apart.

Did you know that viola flowers are edible? Both the leaves and flowers of pansies and violas are edible and high in vitamins A and C. The flowers have a strong flavor and make beautiful garnishes for salad and fruit plates.

Plant some of these cool-season wonders this weekend and enjoy their flowering show.

The unusual colors and textures of low-maintenance ornamental kale take landscapes from safe to sensational during the winter months.

Purple Moon kale has deep-purple frilled and ruffled leaves that look great with Matrix pansies.

Colorful Kale Brightens
Winter Gardens

Pansies and viola bring vivid hues to many gardens during the winter months, but adding the engaging colors and textures of ornamental kale takes a landscape from safe to *sensational*.

Skeptical? You're not alone. Comments I have heard about ornamental kale include, "You only see it planted in commercial landscapes," and, "It's not for the average home garden." I used to be in this group until I saw the light, or I should say, the ornamental kale.

While the plants known as ornamental kale are typically seen in commercial landscapes, they are perfect for home landscapes, too, because they are low-maintenance. Who does not like a low-maintenance plant when the temperatures start to dip?

Ornamental kale is available in a variety of unusual color combinations. The colors in the center of the plants range from whites and pinks to purples. The colors intensify as the temperatures drop.

Different leaf textures and types, such as feathery, crinkled, or round, should be planted together to increase contrast.

An ornamental kale that has performed really well in Mississippi for several years is called Redbor. The crinkly leaves of Redbor turn an incredible dark red through the winter months. Plant Redbor with a white version called Winterbor to create an attention-getting landscape combination. I love the new introduction of Purple Moon, having deep-purple frilled and ruffled leaves.

Ornamental kale needs to be planted in well-drained soil that is kept consistently moist. This is a vigorously growing plant that needs steady nutrition. I always add about one tablespoon of slow-release fertilizer directly into the transplant hole. Later in the winter season, a dose of water-soluble fertilizer every month will keep your ornamental kale happy and beautiful.

The only real insect pests are cabbage loopers and related insects, and these are the same ones that like the other cole crops, such as broccoli, cauliflower, Brussels sprouts, and cabbage. Reliable pest control can be

Kale chips are a nutritious snack with that satisfying crunch.

maintained with *Bacillus thuringensis* (Bt). I prefer to use products containing the active ingredient spinosad. Both of these are good choices, especially for edible crops.

Ornamental kale is a very close relative to broccoli. Like its vegetable-garden cousins, it is edible and is often used as a garnish. It's a good source of vitamin C, calcium, and beta carotene. But what about actually cooking with it? Ornamental kale has been selected for color in the garden, but prolonged cooking fades the colors.

To set the colors, quickly blanch the kale and then put it in an ice bath. Cut the leaves into strips and add to your dish during the last few minutes of cooking for a tasty, nutritious, and colorful addition to dinner.

We like kale chips in the Bachman household, and you can try it, too.

Preheat the oven to 260 degrees. As ovens differ in performance, you may have to adjust your temperature and times to get the kale chips exactly how you like them. I like the fringed varieties, as they seem to get crispier. Trim the thick mid-rib out, as it will never get crispy.

Lightly coat the leaves with extra-virgin olive oil and sprinkle with sea salt. Spread the kale out into a single layer on a cookie sheet and bake for about 20 minutes. Mix the kale around, and put it back in the oven with the heat turned off. Leave the kale in the oven for another 15 minutes.

My daughter taught me how to make kale chips in an air fryer, and it is now my favorite method. Prep the kale as before, but air-fry at 275 degrees for 15 minutes and you're done.

Whether you want your landscape to be strictly ornamental or also edible, try some ornamental kale this winter for a unique addition to your garden.

Snapdragons Meet
Winter Challenges

The snapdragon is a longtime favorite flower of mine for the cool-season landscape.

Many home gardeners seem surprised when I tell them snapdragons are pretty tolerant of cold weather. We are lucky to be able to grow these great landscape plants in Mississippi from the cool of fall to the rising temperatures of spring. Once planted and acclimated, snapdragons seem to say, "Bring on the cold weather."

An old standby is the Sonnet snapdragon. With colorful flower spikes available in a kaleidoscope of colors, it is easy to see why Sonnet snapdragons are so popular. Flower colors include orange, scarlet, pink, white, and yellow.

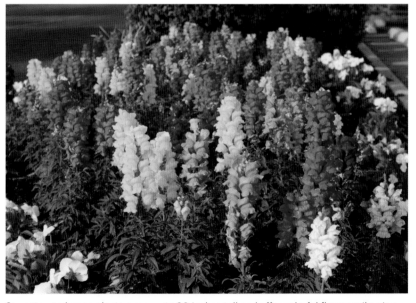

Sonnet snapdragon plants grow up to 30 inches tall and offer colorful flower spikes in a kaleidoscope of shades that are great as cut flowers. They are thrilling in a cool-season combination container and have a soft cinnamon scent.

Snapshot Mix are bushy, compact snapdragons topped by closely spaced, full flower spikes.

Twinny Yellow Shades has gorgeous double flowers displaying distinct shades of peach, yellow, and light orange.

These plants, which grow up to 30 inches tall with numerous flower spikes, are thrilling in a cool-season combination container. They are also great for cut flowers and have a soft cinnamon scent.

If you don't want to have big and tall snapdragons, there are nice dwarf-growing types. One of the best is the Montego series.

Montego snapdragons grow to only 10 inches tall and wide. Like their big cousins, they are available in a variety of colors that would be gorgeous lining the front edge of a flower bed, including red, yellow, white, pink, and bicolor.

These plants are ideal for planting in the full sun to partial shade. The individual flowers are aligned neatly and tightly bundled on the many stems. The flowers are big for the size of the plant, so it's good that the Montego snapdragons have strong and sturdy stems. The flower heads stay compact and do not stretch when the weather warms in spring.

Another good dwarf snapdragon is any selection in the Snapshot series. These plants are a little shorter than the Montego, reaching 6 to 10 inches tall, but they spread up to 14 inches. They offer plenty of flowers in soft, pastel colors, as well as bicolors and a mixture.

I would be remiss if I didn't at least mention the Twinny compact snapdragons. I like these plants because of their double flowers that are sometimes called "butterfly blooms."

Twinny Peach was an All-America Selection in 2010 and has gorgeous flowers of distinct shades of peach, yellow, and light orange. The Yellow Shades selection has flowers that are a beautiful combination of orangey yellows.

Snapdragons require only a little bit of care to keep them looking good. Deadheading will keep them blooming and looking tidy. These plants tolerate low temperatures, but to prepare for extremely cold nights, cover them with a sheet or box until the cold spell passes.

Plant them in a well-drained landscape bed or container. Snapdragons need consistent moisture but don't like wet feet. When planting, put a teaspoon of slow-release fertilizer in the hole first to keep the plants well fed. When warmer weather arrives in the spring, feed them again for a great colorful display.

DECEMBER

Autumn Leaves poinsettia is a warm-colored poinsettia with peachy yellow mixed with a pale-pink-colored bracts.

Princettia are a newer introduction having a more compact growth habit and a great color display.

Color Choices Give
Poinsettias Variety

In their native Mexico, the bright red flowers of poinsettia are known as *Flores de la Noche Buena*—or Flowers of the Holy Night—as they bloom each year during the Christmas season.

If you're a fan of poinsettias but like variety, you'll find the range of poinsettia colors available is truly remarkable. Poinsettia is no longer simply "that red Christmas plant." Colors range from red and white to even maroon for Bulldog fans, making it hard to choose. In addition to solid colors, there are bicolor, speckled, and marbled poinsettias. There are even nontraditional Christmas colors like the peachy Autumn Leaves.

A new type of poinsettia has come to the market and is called Princettia. Available in a variety of colors these plants are more compact with smaller bracts than traditional poinsettias. These plants have prolific branching supporting more color. Look for them at your favorite garden center.

When shopping for poinsettias, be ready for the wide variety of options, and take your time to select the very best. Bracts should be completely colored and fully expanded. If not, the plants were probably shipped before they were completely ready.

You can hardly go wrong with these colorful "flowers" brightening your holiday decorations. However, what we think of as flowers are actually modified leaves called "bracts." The true flowers are the yellow-green bead-like structures called "cyathia." Your poinsettia will last longer if you select plants with unopened or only partially opened cyathia.

In recent years, growers and florists have been using poinsettias in combination containers. I love the combination of red poinsettia with the Mississippi Medallion winner Diamond Frost euphorbia. Another combination to try is snow-white chrysanthemum with a traditional red poinsettia.

Follow a few care tips to help keep your poinsettia looking good long after the Christmas holidays. Poinsettias need at least six hours of in-

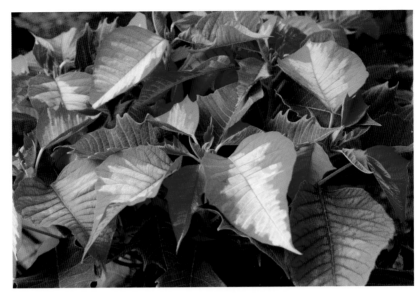

Poinsettias such as this Ice Punch selection are part of the expected scenery and decorations of Christmas. They come in a wide variety of colors and styles, and, with a little care, they can last past the holiday season.

direct sunlight and comfortable room temperatures. When grown in the greenhouse, the temperatures are about 72 degrees during the day and 60 degrees at night. The closer you get to providing these same temperatures, the longer your poinsettia will last.

Don't let the leaves or bracts touch window glass, as the low outside temperatures are readily transferred through the glass. Also, keep poinsettias away from frequently opened doors. It might look great by the front door when guests arrive, but, if you want the plant to look great later, avoid the sudden temperature changes.

Temperatures below 50 degrees can harm the foliage and colorful bracts.

On the way home with your new poinsettias, be sure to cover them carefully, taking care not to break any branches or stems. Poinsettias are fragile, and stems can break quite easily from mishandling. Not only can the paper or plastic shipping sleeves hide damage, but you should pay particular attention when removing these. Never try to slide one over the plant, but always tear or cut the sleeve off.

The absolute most important thing to remember is *do not* overwater your poinsettia.

Poinsettias are sensitive to wet feet, and root rot sets in quickly. Make sure the potting mix feels dry to the touch before you water it. Remove the decorative sleeve around the pot, and water the top of the container over the kitchen sink. Replace the decorative sleeve after the water has finished draining.

While poinsettias are not poisonous to our pets, according to ASPCA Animal Poison Control, a pet that eats poinsettia leaves will most likely experience GI tract irritation. Ornamental and houseplants are not meant to be eaten by our animals, so keep the poinsettia out of reach of pets.

Some humans may be sensitive to the milky latex sap in the poinsettia, which may cause a skin rash or contact dermatitis. Always wash your hands thoroughly after handling a poinsettia.

Whichever colors and combinations you choose, be sure to brighten your Christmas celebrations with your favorite poinsettias.

A tree-shaped rosemary plant can make a fun and aromatic miniature Christmas tree to brighten up holiday homes.

Rosemary Makes a Unique Christmas Decoration

Christmas is one of my favorite times of the year, because I get to enjoy indoors the scents and colors of the garden. Christmas looks like poinsettias, live trees indoors, and greenery decorating the house, and it smells like pine, cedar, fir, and, in my house, rosemary.

In addition to the traditional holiday staples, Christmas isn't Christmas at my house unless there is a rosemary plant shaped and decorated like a Christmas tree. These plants are available at many garden centers, grocery stores, and other plant outlets.

Rosemary's needle-like leaves resemble a miniature Christmas tree. The leaves are typically a dark green with silvery undersides. They also are very aromatic. I can't help touching the plants every time I walk by, releasing the sweet scent.

Rosemary is one of my favorite herbs for cooking. The sweet aroma makes the kitchen an inviting place, and it accompanies so many different cooking styles and menu items. But let's face it: rosemary can sometimes be tough to grow, especially if it's given too much care.

One of the best garden attributes of rosemary is that it thrives on neglect.

Make sure your plant has good drainage and receives full sun for at least six hours each day. Never try to grow from seed; this process takes more patience than most gardeners have. I suggest buying one of the improved selections from the nursery. There are even trailing selections that are great for hanging baskets.

Growing the plants in containers really simplifies growing great rosemary. Place a potted rosemary in a sunny window, where it is easy to snap off a bit to add to hearty winter meals.

While rosemary grown outdoors is considered a drought-tolerant plant, plants grown indoors in containers should stay moist. The plant's root system can be quite extensive, and, in a container, it can quickly deplete the available water.

A popular garden Christmas gift is a rosemary plant trained in the Christmas tree shape.

These holiday plants are fine inside for a couple of months, but rosemary is not considered an indoor plant. After New Year's, go ahead and place the container outside on the patio or porch. Since rosemary is hardy to only about 25 degrees, bring it back inside if temperatures are expected to dip lower than that.

In most years in Mississippi, rosemary is quite happy being a fragrant and tasty landscape shrub. Use the fresh, new growth for recipes. Regular clipping keeps the fresh growth going strong.

One thing you may not know about rosemary is that it may help to improve your memory. In ancient times, philosophy students would place sprigs behind their ears to improve study for examinations. Some modern research seems to agree that this helps. The pleasant scent of rosemary has enhanced children's academic performance and may be a great study aid.

So, during the winter months, there are a few more reasons to bring your rosemary indoors and enjoy this versatile plant.

Cassia Provides Blooms as Temperatures Drop

Some folks think winter can be boring in the garden and landscape. But when temperatures start to drop, one of my favorite flowering plants decides to suddenly strut its stuff for all to see.

Wherever cassia is planted in the landscape, the tropical-looking flowers are sure to create winter interest.

The prolific winter blooms of winter cassia make it a show-stopping plant. The effect is heightened because the brightly colored blooms seem to appear out of nowhere. Winter cassia is also called "Christmas Senna" because it is commonly in full glory at this time.

Beginning in November, the golden-yellow flowers are displayed in loose clusters, each having up to twelve individual blossoms. Individual flowers have five petals and curved stamens and pistils.

Winter cassia in full bloom sprawling out from a cast-iron fence is a gorgeous winter sight.

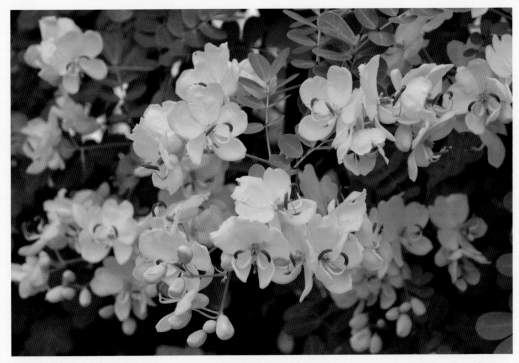

The prolific blooms of winter cassia make it a show-stopping plant. Blooms begin in November and are displayed in loose clusters.

Candelabra Cassia has bright-yellow, cup-shaped flowers that are grouped together, resembling a candlestick. Its huge leaves add a tropical flair to the landscape.

The large flower clusters form toward the ends of the slender branches and can be so heavy that the branches are pulled down, giving many plants a vase-shaped form. This effect is accentuated after a rain or heavy dew.

The leaves are pinnately compound, with three to five pairs of oval-shaped leaflets. Foliage is a deep green in the summer, but, with falling temperatures, they become greenish-yellow. While the leaf shape and color do have landscape value, winter cassia primarily fills in garden gaps and provides a consistent backdrop for more showy summer plants.

Another cassia with a lot of landscape interest is candelabra cassia, or candlestick cassia. This plant is not nearly as commonly grown as winter cassia. It has bright-yellow, cup-shaped flowers that are grouped in upright clusters and resemble a candlestick.

This is a much bigger plant than winter cassia and can grow to about eight feet tall. The huge leaves add a tropical flair to the landscape. The pinnately compound leaves are up to 30 inches long, with individual leaflets being 5 to 6 inches long and 2 to 3 inches wide.

This is a tropical plant, and, in the coastal counties, it will commonly die back to the ground during the winter but return in the spring. In northern Mississippi, grow candelabra cassia as a lush, tropical annual.

Plant all cassias in full sun to produce the best flowering. Good drainage is a must; cassia does not like wet feet, but it also does not tolerate droughty soil conditions. Each spring, top-dress the plants with a good-quality compost or sprinkle them with a handful of controlled-release fertilizer to keep your winter cassia healthy.

Since these plants originated in the tropics, you must provide some winter protection. When night temperatures start getting into the lower thirties, apply a layer of pine straw or other mulch around the base of the plant to help provide insulation.

Winter can be dry, so water once a month if there has not been much rainfall. This is a good idea to follow for all of our landscape trees and shrubs.

If you're looking for a multitasking plant, choose cassia for winter and summer enjoyment.

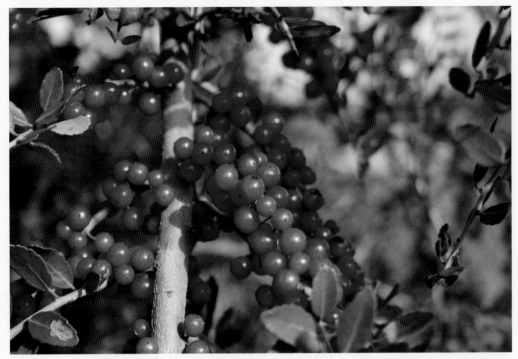

The Mississippi native yaupon holly can be seen popping out of woodland edges everywhere. Its distinctive berries have a translucent quality that imparts a gem-like appearance.

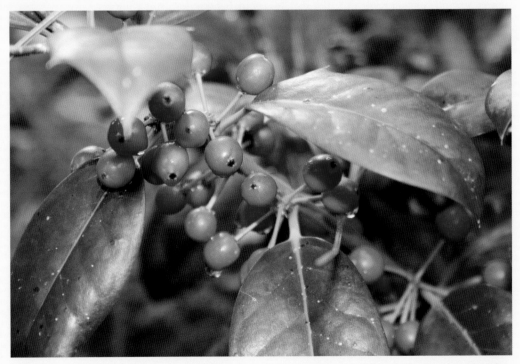

Nellie R. Stevens is a hybrid holly with dark, glossy green leaves year-round and thousands of red berries in the winter.

Hollies Time Their Berry Color for Christmas Displays

The Christmas season is a time for decorating, as we put up lights, wreaths, poinsettias, and trees. But Mother Nature is in on the plan, too. I love the timing that allows our landscape hollies to get into the decorating action with their bright and colorful berry displays.

The most prevalent holly berries we see right now in Mississippi are on our native yaupon holly.

If you drive any distance, you will see this plant on full display, as it seems to literally pop out of woodland edges everywhere.

Yaupon holly has very distinctive berries. Sure, they're red—and I mean bright, candy-apple red—but they also have a translucent quality that imparts a gem-like appearance. So, in other words, yaupon hollies are garden jewels that will sparkle in your landscape.

But yaupon hollies provide color beyond just their berries. The bark of yaupon is a bright gray that accentuates the berry color.

The native yaupon holly should actually be called a small tree, as it grows up to 20 feet tall. Its size could overwhelm a typical home landscape, but a couple of interesting selections are landscape worthy. Weeping yaupon is a small tree that can grow to about 12 feet high, and its branches have a weeping, cascading growth habit.

Nellie R. Stevens is a hybrid holly that is a wintertime favorite. Its leaves are a dark, glossy green year-round, and it has a nice, triangular growing habit. But the real attraction is its berry production—literally thousands of brightly colored red berries.

Nellie R. Stevens has the potential to be a big plant—up to 20 feet tall and wide. It is tough and durable and tolerates pruning to keep it under control, but the best practice is to plant it in a space that will accept the growth potential. Prune merely to shape and maintain the pyramidal form.

Savannah holly is another wonderful plant for a winter berry display. The heavy berry production can be a real showstopper from November

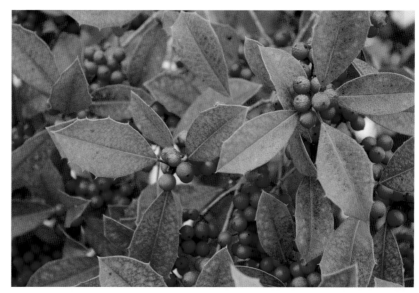

Savannah holly displays tight clusters of fluorescent red berries during the winter months.

through March. The tight clusters of berries are formed toward the ends of the branches. The berry color is reminiscent of fluorescent red and are a quarter inch or more in diameter.

Because of the plant's impeccable timing, the berries color up at exactly the right time and are perfect for homemade Christmas wreaths and decorative garlands. Or, why not bring some of the dazzling displays of red berries indoors? Trim some branches and bring them indoors for a winter arrangement on the table or fireplace mantle. What can be more appropriate heading into the holiday season than decorating with something gathered from your landscape?

Along with adding beauty to our landscapes and tablescapes, these winter-fruiting hollies play an important role as a food source for wildlife. They also provide habitat for nesting birds.

If you are looking for a way to bring seasonal color into your landscape, consider the year-round beauty of a Mississippi native yaupon holly or a beautiful hybrid.

Mississippi Gardens Can Produce Fresh Citrus Fruit

There's nothing like reaching into the toe of your Christmas stocking and finding a fresh and tasty satsuma orange that came right from your own garden.

I'd like to say I've done that, but, so far, all the fresh satsumas I've enjoyed have come from my friend Terry's house. Let me just say that I don't have to worry about scurvy for a while.

Having enjoyed Terry's satsumas so much, I just went out and bought the first of what probably will be several satsuma orange trees that I will

Satsuma oranges grow well in Mississippi and produce very juicy fruits with deep-orange rinds.

Kumquat is another citrus that can be grown in the state. These small, orange-colored fruit are eaten whole, and the sweet peel contrasts well with the slightly sour inner sections.

Kumquat tree.

own. I'm not the only fan of these oranges. Some of the most popular small fruits grown in Mississippi are the various citrus species.

I wasn't sure what a satsuma was until I moved to the Gulf Coast. Satsuma oranges are related to mandarin oranges. These are very juicy fruits with deep-orange rinds that, with practice, can be peeled in one piece.

Satsuma orange trees can produce a lot of tasty fruit. Most home gardeners prune to control the plant size, make harvest easier, and keep the plant more manageable. If left unpruned, you must support the branches to keep the heavy fruit load from damaging the trees.

Other citrus I'm beginning to enjoy are kumquats and Meyer lemons.

Kumquats produce an orange-colored fruit that is one to two inches in diameter. Before you worry that peeling such a small fruit will be a lot of work, let me point out that you don't peel kumquats. You eat them peel and all, except for the occasional seed.

I find the peel is sweet and contrasts well with the slightly sour inner sections. Kumquat trees produce an abundance of these delicious fruit.

The fruit produced by Meyer lemon trees doesn't look like the lemons you see in grocery stores. This fruit is actually thought to be a cross between a lemon and an orange. Meyer lemons are large, thin-skinned, and very juicy. They are also a little sweeter than true lemons.

DECEMBER

A cross between a lemon and an orange, Meyer lemons are large, thin-skinned, very juicy, and a little sweeter than grocery lemons.

The best-producing satsuma plants, as well as other citrus plants, are usually those grafted onto a vigorously growing rootstock that is more tolerant of winter weather. During extreme cold temperatures where winter protection is not available, home gardeners can have problems with the citrus graft dying.

Sometimes the rootstock may start growing but produce inedible fruit. Other times, the rootstock starts growing and becomes a problem. When this happens, the rootstock typically produces a thorny stem that should be removed.

If your taste buds are telling you to go buy a satsuma tree, I must tell you that, unfortunately, their range is limited. Gardeners in coastal counties are the only ones who can grow satsuma oranges in-ground, because of the plant's sensitivity to cold temperatures.

The good news for gardeners north of the coast is that satsuma oranges, kumquats, and Meyer lemons grow and produce well in containers. Growing them in containers gives you more options for providing winter protection, and you can even move the plants indoors during extreme weather.

For more information about growing satsumas and other citrus trees, go online or ask your local county Extension office for a copy of the Extension publication "Growing Citrus in Containers in Mississippi." This is an excellent guide to being successful growing citrus in your garden or landscape.

Index

About the Author

Photo by Mississippi State University Extension Service, Michaela Parker.

Gary R. Bachman is well known as the voice and face of the Mississippi State University Extension Service's award-winning *Southern Gardening* television, newspaper, radio, and social media franchise. Through his personal, conversational style, Bachman has made tremendous impacts with consumers of horticultural products and services in Mississippi and across the Southeast.